CAIRO PAPERS
IN SOCIAL SCIENCE
Volume 24, Number 4, Winter 2001

THE TERMS OF EMPOWERMENT: ISLAMIC WOMEN ACTIVISTS IN EGYPT

Sherine Hafez

THE AMERICAN UNIVERSITY IN CAIRO PRESS

Copyright © 2003 by the American University in Cairo Press
113, Sharia Kasr el Aini, Cairo, Egypt
420 Fifth Avenue, New York, NY 10018
www.aucpress.com

All rights reserved. No part of this publication may be reproduced, stored in a retrieval system, or transmitted in any form or by any means, electronic, mechanical, photocopying, recording or otherwise, without prior written permission of the copyright owner.

Dar el Kutub No. 3255/03
ISBN 977 424 803 1

Printed in Egypt

CONTENTS

ACKNOWLEDGMENTS -- v

CHAPTER ONE: INTRODUCTION: ISLAMIC WOMEN'S
ACTIVISM: VOICE OR SILENCE?-------------------------------------- 1
 Research Goals -- 3
 Research Methods -- 6
 Entering the Field --- 8
 Islamic Women Activists in Contemporary Social Science
 Literature -- 9

CHAPTER TWO: ISLAMISM AND WOMEN'S MOVEMENT:
UNDERLYING THEMES FROM THE 1800s TO THE PRESENT - 21
 Modern State Building --- 22
 Liberal Projects of Reform -------------------------------------- 25
 Revolution and Nation Building -------------------------------- 28
 The Period of *Infitah*, Capitalism and Islamic Resurgence ----------- 29
 An Islamic Women's Movement -------------------------------- 31
 Islamic Women's Scholarship Activism ----------------------- 33
 Iranian Islamic Feminism -- 40

CHAPTER THREE: EMPOWERING THE SELF:
TRADITION, PATRIARCHY AND ISLAMISM --------------------- 47
 Research Setting -- 49
 Forging Bonds to Better Selves --------------------------------- 57
 A Women's Empire -- 61
 Discipline and the Attainment of the Ideal -------------------- 64
 Gender Roles: The Domestic as Worship ---------------------- 69
 A Sense of Empowerment --------------------------------------- 73
 Finding Space for Empowerment ------------------------------- 76

CHAPTER FOUR: THE TERMS OF EMPOWERMENT ------------ 79
 From Development to Empowerment -------------------------- 81
 Understanding Notions of the Self in the Middle East --------------- 83
 A Foucauldian View of the Self -------------------------------- 86

CHAPTER FIVE: RESEARCH FINDINGS AND CONCLUSION -- 92
 Sherine Fathi: A Star Preacher --- 93
 Preaching in Egypt: A Social Phenomenon --------------------------- 94
 Islamic Women in the Middle East ------------------------------------ 97

REFERENCES --- 107

ABOUT THE AUTHOR --- 114

ACKNOWLEDGMENTS

I would like to express my gratitude to the members of my thesis committee; to my thesis advisor Dr. Soraya Altorki for her immense contributions which have made this study possible, and to my thesis reader Dr. Suad Joseph who gave me much needed encouragement and support. I am indebted to her for her interest in my work and her most valuable contributions. I owe a huge debt of gratitude to Dr. Mark Allen Peterson for his unfailing help throughout. His remarkable patience and meticulous reviewing and editing of this manuscript were instrumental in its creation. Last, but not least my sincerest thanks to Ms. Reem Mirshak for all her valuable help with important logistics and for being a professional of the highest standards.

This thesis owes its immediate inspiration to three women I know, my mother Naglaa Sirry, my mother–in law Enayat Nasser and my daughter Hana al-Gamal, who invite me every day to witness the various terms of empowerment.

My heartfelt thanks to the members of my family, my husband, Hassan al-Gamal, my son Ziad al-Gamal and my daughter Hana al-Gamal for their selfless support of my work and for their unconditional forgiveness when I was at my worst.

I would like to thank my friends who, after being set aside for so long continue, to be my friends.

CHAPTER ONE

ISLAMIC WOMEN'S ACTIVISM: VOICE OR SILENCE?

In 1995, led by the following slogan articulated in the Beijing NGO forum: "As a Muslim woman I have an opinion,"[1] Islamic women activists initiated a new campaign opting for an independent, gender-sensitive interpretation of the Qur'anic texts. Contesting the position of women in the Middle East and the Arab world, this group of Muslim women is basing their activism on a "contemporary"[2] perspective often relying on knowledge of social science and *ijtihad* (independent reasoning). The ensuing Islamic women's discourse is being widely publicized as more women challenge one of the strongest foundations of male dominance in the Middle East. Among such women are Heba Raouf Ezzat[3] and Amina Wadud-Muhsin,[4] who are contributing to the creation of a contemporary dialogue between women and Islam. What sets these figures apart from other Islamic activists is their vision of a revival of the position of women based on an Islamic paradigm that they believe will empower themselves and others to implement changes for women within whatever social sphere they operate.

The appearance of such pro-women discourses was heralded in some of the recent literature as the birth of an "Islamic feminism."[5] Authors combine post-modernist definitions of "feminism" with notions of "authenticity" to construct a framework that seeks to explain a contradiction in terms: "Islamic," with its connotations in modernist discourses of tradition and

[1] Lene Kofoed Rasmussen, "Muslim Women and Intellectual(s) in 20th Century Egyptian Public Debate." Paper presented in the Fourth Nordic Conference on Middle Eastern Studies, Oslo, 1998, p.1
[2] By contemporary, I mean interpretations of Islam that are concerned with issues such as democracy, women's rights, freedom of thought, and promoting human progress. The argument is that both Muslims and religious piety itself would benefit from reforms and a more open society.
[3] Heba Raouf Ezzat, *Women and Political Work: An Islamist Perspective* (Washington: International Institute of Islamic Thought, 1992).
[4] Amina Wadud-Muhsin, *Qur'an and Woman* (Kuala Lumpur: Fajar Bakr, 1992).
[5] Miriam Cooke, *Women Claim Islam: Creating Islamic Feminism Through Literature* (New York: Routledge, 2001).

backwardness, and "feminism," which is posited as the liberal modernist answer to women's liberation. This dilemma has resulted in much of the literature's preoccupation with reconciling the two camps rather than escaping the constrictions of liberal modernist notions of tradition vs. modernity. In his criticism of social science projects that attempt to understand Islamic movements from within this paradigm, Talal Asad argues that, " ... one needs to recognize that when one talks about tradition, one should be talking about, in a sense, a dimension of social life and not a stage of social development."[6]

In this research I will follow Asad's counsel in mapping out a theoretical framework that seeks an understanding of Islamic women's activism neither as an indigenous form of "feminism"—regardless of how that is defined—nor as a backward relapse into, or an invention of, tradition, but rather as a type of women's activism by which women are empowered in what is largely a patriarchal society. However, this premise is not merely of a theoretical nature; it has transpired out of the quality of my engagement with the women who served as my hosts, friends, mentors and informants. While throughout this engagement the bulk of my concern was with whether these women fit into definitions of feminism or "tradition," Islamic women activists, on the other hand, were concerned with an entirely different project. Theirs was a preoccupation with self-perfection to attain a proximity to God. To these women, activism as a service to others lies at the heart of this process of perfecting the self. Contesting male authority, resistance, and the various strategies for empowerment as defined by feminist scholarship are but unintended after-effects of the pursuit of higher religious attainment. My theoretical focus on "empowerment" represents a compromise between my focus on social change and their focus on piety. Ultimately, I will argue that the language of most contemporary feminist scholarship is inadequate to describe the work of these women I am calling Islamic activists, and the nature of their engagement with power.

[6] Saba, Mahmood, "Interview with Talal Asad: Modern Power and the Reconfiguration of Religious Traditions," *Stanford Electronic Humanities Review*, vol. 5:1, Feb. 1996.

Research Goals

In investigating Islamic women's activism,[7] with a focus on the Islamic women's movement in Cairo, my goal is to interpret the impact of their activism on women's self-empowerment. I base my study on a group of Islamic women activists who have emerged from Egypt's temperamental social and political climate as leaders and active participants in an Islamic women's movement in the public domain. In the course of my fieldwork, I have come to know numbers of Islamic women of all ages and socioeconomic levels who preach, give religious lessons, teach illiterate girls and who work for philanthropic causes as well as contribute to the management and organization of Islamic women centers in Cairo. Though the two groups of Islamic activist women that I worked with showed a diversity in background, they were united around the common goal of perfecting themselves as means of gaining proximity to God. In their various endeavors to achieve this goal, they were engaged in processes that invoked in them a sense of empowerment. The women I studied are part of an Islamic women's movement in Egypt that works towards their own self-development as well as that of society at large.

This study is concerned with asking how Egyptian women find empowerment in Islamism when Islamists are traditionally perceived as the opposers of women's liberation in Egypt. What is this kind of empowerment that Islamic women derive from their activities? How can Islamic women's activism empower Muslim women in Egypt today? To search for answers to these questions without representing the Islamic women's movement in Cairo as a stage in the progression of Egyptian society towards the grand narrative notion of modernity, it is important to elevate the discussion to one that understands these Islamic women as situated within the specific historical circumstances that influenced them. The following study will show that Islamic women's activism in Egypt is producing an Islamic movement that redefines the role of women in society. Imbued with

[7] Islamic women's activism is diverse and is led by various groups of Islamic women in Cairo. These groups show a diversity of socioeconomic class, levels of education, as well as perspectives which vary with regards to whether they find that the state should follow *shari'a* law. These categories however, should not imply that groups and individuals do not change perspectives. I use the expression Islamic women's activism not as a collective, nor theoretically, but for the sake of convenience.

religious legitimacy, it recasts women from a traditionally ascribed marginality into wider public spheres once exclusively occupied by men. I will argue that as these women literally invade the domain of the mosques and the centers of the religious establishment, they are highly aware that they contest male power. Yet they are spurred on not by a general desire to fight patriarchal sentiments, but because they are driven by a religious impetus to perfect their relationship with God and to contribute towards the well being of others. As they frame and influence responses to dominant ideologies, they constrain hegemonic male discourses that have undermined women in society as a whole. Islamic women mobilize through formal and informal means to create an Islamic activism that benefits women through preaching, education, and philanthropic activities. Islamic women act to dismantle the myths that have impeded the participation of women in the religious, social and political arenas of the country.

Although Islamic women activists constitute a diverse group in contemporary Egyptian society, they can be predominantly characterized by an Islamic zeal aimed at attaining higher levels of religiosity and self-enhancement. Their commitment to addressing wider social causes and concerns is noted throughout the country, providing tangible results that attest to their skills and organizational abilities. I argue that Islamic women activists submit themselves to religious *'ibadat* (ritual worship) and *mo'amalat* (religiously dictated behavior) as a means to that self-refinement, which Foucault calls "technologies of the self." He defines the term as disciplines by which human beings transform themselves to attain an improved state of being.[8] This improved state of being is influenced in Egypt by the image of the ideal Muslim woman in contemporary Islamic discourse as constructed by Islamist ideology, which posits it to counter colonialist Orientalist attacks against Islamic society and its beliefs.[9] Whereas Islamic women are often perceived as dominated and oppressed, this study contends that Islamic women are empowered as a result of their willing submission to higher levels of religious attainment. While remaining embedded within social systems that have often been criticized as the cause

[8] Michel Foucault, "Technologies of the Self" in *Technologies of the Self: A Seminar with Michel Foucault* (Amherst: University of Massachusetts Press, 1988)) p. 18.
[9] Lazrag Marnia, *The Eloquence of Silence. Algerian Women in Question* (New York: Routledge, 1994).

of their oppression, namely patriarchal systems, Islamic women are "empowered" in a sense that challenges globalized contemporary notions of the concept because their empowerment is predicated upon indigenous Islamic criteria and not on Western liberal frameworks of analysis. Although they compete with male hegemony over the religious sphere, Islamic women nevertheless concede to male authority if they view it as justified by Islamic teaching. This position contradicts feminist paradigms, which have traditionally named patriarchy as its long-term enemy.[10]

My research project goals are: to interpret the impact of Islamic women's activism on women's empowerment, to understand what empowerment represents for these women in terms that make sense to them, and to assess the potential of an Islamic pro-women approach to address issues of empowerment across social and economic levels in society. Lastly, I hope to bring forth the women who find in Islamic ideology an answer to society's needs, including those of women. I aim to address these goals through a consideration of the historically and culturally specific dynamics that contribute to the creation of women's empowerment in Egypt. I intend to focus my analysis on the nature of the relationship between the women I studied and the social and cultural processes that engendered their notions of self-empowerment.

As Islamic women's groups vary in their scope, orientation, and activism, their empowerment reflects varying degrees of social, psychological, and political forms. This study defines Muslim women's empowerment as the bolstering of women's self-esteem, solidarity, and confidence, which comes from an inner satisfaction brought by the improvements they implement in the community. It is an empowerment that is predicated upon relinquishing the forms of power deriving from overt resistance and relies instead on notions of perseverance, submission and higher levels of religious attainment. In fact, the women I studied defined a condition of empowerment as an improved state of being based on perfecting the self to gain closeness to God. My study shows that many Muslim women today are empowered in an Islamic movement in Egypt through their submission to disciplinary religious practice and behavior. As

[10] Soraya Altorki, "The Concept and Practice of Citizenship in Saudi Arabia" in Suad Joseph, ed., *Gender and Citizenship in the Middle East* (Syracuse: Syracuse University Press, 2000) p .234.

they attain the normative model of femininity, that of the ideal Muslim woman in Islamic tradition, these women engage with experiences and opportunities that stimulate an empowerment that is indigenous and unique to them.

Research Methods

Egypt provides an ideal venue for studying women who use Islam as a framework for activism. That is because while Egypt is a predominantly Muslim country, it is not an Islamic state. Islamic states such as Iran are believed by some scholars to sponsor and therefore manipulate women-centered movements.[11] Egypt has recently based its *qanun al-ahwal al-shakhsia* (personal status law) on the Islamic *shari'a* (jurisprudence), which creates various constraints on women. In response to the United Nations Convention on the "Elimination of All Forms of Discrimination Against Women," the Egyptian government restricted the rights of women as pertaining to the Muslim law by stating that no one "may call into question" these laws.[12] This provides a challenge to Egyptian women, among whom are those who argue they have the right to contest a male-centric interpretation of the Islamic *shari'a*. While to a large degree Islamic women operate independently from the state, having no sanctioned access to the political forum, their activities have far reaching effects as the study hopes to show. Their marginalization, which is particular to Egypt, provides this study with a scope not afforded by studying other Islamic countries such as Iran, where the government may manipulate Islamic women's activism in order to further its interests. Islamic women's marginalization in Egypt brings to light their ability to create agency through their own channels of participation, while their independence from state control allows for more self-expression and freedom to choose a woman-centered Islamic activism.

I based my study of Islamic women's activism on field research of a narrow sample of women from the Islamic community. By that, I hope to

[11] Haideh Moghissi, *Feminism and Islamic Fundamentalism: The Limits of Postmodern Analysis* (London: Zed Books, 1999).
[12] Nadia Hijab, "Islam, Social Change and the Reality of Arab Women's Lives" in Yvonne Yazbeck Haddad and John Esposito, eds., *Islam, Gender, and Social Change* (New York: Oxford University Press, 1998) pp. 46-47.

provide the research with context and depth given the time element. The two Islamic private voluntary organizations[13] (PVOs) al-Hilal and al-Fath are each run by a different group of Islamic activist women. Both centers are funded through individual efforts and are guided by Islamic principles, which inspire their goals, methods, and the nature of their activities. They were chosen primarily to represent the diversity in Islamic women's organizations to provide the research project with a comprehensive fieldwork experience. Al-Fath is aimed at helping widowed women and their families, while al-Hilal focuses on teaching vocational skills, providing child care and work opportunities. Moreover, both centers are actively engaged in providing religious lessons to women and children on regular bases.

I attended religious lessons for women in three mosques in Cairo: the two mosques attached to the PVOs, namely al-Hilal and the mosque of Abu Bakr, and the mosque of al-Nasr, an independent structure in Nasr City.[14] I also observed a number of lessons in private homes where women preached. Three of them were given in the context of funerals. I conducted thirty intensive, one-on-one interviews with Islamic women activists. Most of these interviews were in the form of conversations that were generally open-ended, but during which I often asked questions. The questions I asked in my fieldwork focused on drawing out the effects that an Islamic women's activism has had on women's status, and empowerment in society on the levels of the personal and the political. I sought their views, reflections on their activism, their notions of themselves and others. I explored their personal perspectives on the relationship between Islam and women. What they hoped to accomplish, what obstacles they anticipated, and how they planned to overcome them were subjects that helped focus these open-ended interviews. One important aspect of my conversations with all my informants was the notion of religious discipline and how they viewed the ideal woman.

In addition to researching their arguments and methods through fieldwork and interviews, I examined contemporary Islamic women's

[13] Private Voluntary Organizations are controlled by MOSA (Ministry of Social Affairs) according to Law 32 of 1964. This law regulates the activities as well as ensures their non-political nature.

[14] Names of places and people have been changed to maintain confidentiality.

scholarly work, taped sermons, articles, and journalism, and reviewed a number of Islamic women's websites. The proliferating Islamist information on the World Wide Web helped provide perspective on the wider contexts of the Islamic women's debate. A number of interviews took place with two Egyptian Islamic intellectuals and writers who are well known for their Islamic scholarship on women, Heba Raouf Ezzat and Omaima Abu Bakr. These women labor among intellectual circles to produce a woman-centered Islamic reinterpretation based on the Qur'anic texts. I participated in visits to Ezzat's home and visited Abu Bakr at her workplace.

Entering the Field

My pursuit of the subject of women who are Islamic activists propelled me through a roller coaster of contradictory perspectives as I struggled to understand the social world in which they lived. I engaged with this research project over a period of almost a year in sporadic spurts depending on time constraints, searching for willing research subjects and appropriate research sites. To prepare myself for my first fieldwork encounter I waded through the available literature, little of which offered appropriate counsel in understanding these women's mission. Yet when I set out to meet them face to face I was not alone. I brought with me my somewhat liberal secular upbringing, my collection of feminist principles and my eagerness somehow to see those reconciled with my Islamic faith. I initially approached the issue by focusing on notions of resistance, freedom, and autonomy from male domination in society. Hence, I set out armed against a true understanding of the women who sought a closeness to God and possessed a desire for a perfection based on Islamic ideals. To me, starting off on my first mosque visit in the summer of the year 2000, these women were pursuing their own emancipation. I could not have been further from the truth

As a Muslim Egyptian woman, my entry into the field provided a few challenges centering on the initial curiosity and suspicion with which some of the women regarded me. There were several reasons for this. In the first place, many of them could not fathom why anyone would be interested in studying them. This, I was later told by one participant, led some to reason

that I was either sent by the government or by *Rose al-Yusuf* magazine[15] or that I was a spy (especially when I mentioned my affiliations to an American institution in Cairo). All these charges were dismissed because of the fact that some of the women knew me and my family, and a few of the women who worked at the centers where I worked were either American University in Cairo (AUC) graduates themselves or had children in the university, or knew someone who did.

Communicating the nature of my project to the women in my study did not prove to be a simple task. I had to explain to them that I was focusing on an analysis of empowerment in such a way that did not influence their responses. The word "empowerment" does not exist in Arabic, which, though it initially seemed a handicap, produced some of my most enlightening data as both the women and myself discussed the meaning of the term. Eventually, many of the women I worked with became interested in what I was trying to do and generously gave me of their time in order to help me. As time passed my presence became unremarkable and I was able to start taking notes in public without eliciting questioning stares.

Islamic Women Activists in Contemporary Social Science Literature

The Islamic women's project of reviving women's role in society based on Islam is viewed in social science literature as either recourse to the past[16] or an indication of the future.[17] Whether an act of surrender or an act of resistance, my view is that Islamic women activists work from within the conditions in which they are situated for the ultimate welfare of women and society itself. Similar situations have been noted with regard to women in Saudi Arabia in a study by Altorki, in which she notes that whereas men enjoy power on the level of the polity, women control the domestic through monopolizing marital ties between families.[18] These networks, which

[15] This magazine has been leading a three-year campaign against Islamic resurgence and in particular women and men preachers.
[16] Moghissi.
[17] Nadje Sadig Al-Ali, "Feminism and Contemporary Debates in Egypt" in Dawn Chatty and Annika Rabo, eds., *Organizing Women: Formal and Informal Women's Group in the Middle East* (Oxford: Oxford International Publications, 1997).
[18] Soraya Altorki, *Women in Saudi Arabia: Ideology and Behavior Among the Elite* (New York: Columbia University Press, 1986) pp. 24-25.

women maintain through following social information and participating in social exchanges of visits and gifts, afford women greater mobility and autonomy. Yet women are seen as the subordinated victims of religion in feminist discourse, and their compliance to hegemonic power is seen as "false consciousness."[19] Is all surrender, therefore, disempowering, and does resistance alone necessarily amount to empowerment? What are the attributes of empowerment that are predicated upon submission? And, more importantly, is the usage of the terms of empowerment in present-day literature adequate in understanding empowerment that subscribes to values and systems so entirely separated from the ones that produced this usage? While I do not purport to answer all these questions in the following undertaking, I intend to explore the issues involved to gain perspective of the dilemmas that research on the so-called phenomenon of 'Islamic feminism' needs to consider.

The question of power in Middle Eastern societies seldom includes women in its answers, even less so when it refers to Islamic women. Studies on Middle Eastern women's activism have often overlooked Islamic women because these women's efforts were treated as part and parcel of male Islamist movements,[20] and thus any claims for power on women's part were either ignored or misrepresented. Very few, however, have attempted to integrate the efforts of women arguing for their rights from an Islamic perspective amidst these struggles, despite the fact that the Personal Status Laws in many Muslim countries are based on Islamic *shari'a*. Only recently has the significance of understanding Islamic women's potential contributions to the debate over the Personal Status Laws for all national women been pondered. Although anthropological work has exposed the central roles of women in household, kin and community networks, most studies on women's empowerment in the region have centered on formal groups and organizations, which are mostly secular feminist.

More significantly, analytical frameworks used to interpret Islamic women's activism have not always been adequate, as they have tended to

[19] "This implies that the dominant ideology achieves compliance by convincing subordinate groups that the social order in which they live is natural and inevitable." James C. Scott, *Domination and the Arts of Resistance* (New Haven: Yale University Press, 1990) p. 72.

[20] Islamist is here used to denote those who seek an Islamic state as means of government.

project normalized Western paradigms that distorted representations of Islamic activist women by attempting to fit them into these categories of thought. The body of literature on Islamic feminism, which has only recently been produced, shows a pronounced interest in women's Islamic "voice" that rises against its patriarchal oppressors.[21] When not extolling the virtues of women's Islamic feminist movement the literature swerves in the opposite direction, sounding an alarm against the "compliance" of groups of Islamic women with a religious arousal that will only disavow itself of its feminine supporters once it assumes power.[22] Concepts such as feminism and empowerment, as well as citizenship, originate from Western thought and do not ideally lend themselves to interpreting religiously inspired activism in the Middle East, let alone alternative structures maintained by Islamic women to promote their interests. Islam is often posited as the opposite of modern liberal political structures in which the individual is regarded as free, autonomous, and contractual. Moreover, Western feminism attacked religion on the basis that it was a patriarchal system that oppressed women. As this research investigates the diverse discourses of Islamic activism to understand its impact on women's empowerment, it critiques frameworks of analysis produced from the paradigms of Western feminism and modern liberalism, which often inform studies on women's agency and empowerment.

Nevertheless, we must first consider how prevalent theoretical frameworks on women's empowerment in scholarship on power and feminist literature contribute to interpreting women's empowerment in the contemporary Islamic sense. A discussion of the literature addressing "Islamic feminism" cannot be attempted without a consideration of Azza Karam's book *Women, Islamisms, and the State*.[23] Karam surveys the wide spectrum of feminist activism in Egypt and organizes them into three ideological categories, from secular feminists to Muslim feminists to Islamist feminists. It is here that the term "Islamic feminist" receives its most comprehensive treatment to date. Like others who use the term to describe Islamic women activists, Karam uses a post-modernist definition of

[21] For one such narrative see Cooke.
[22] Moghissi represents such a view.
[23] Azza Karam, *Women, Islamisms and the State* (New York: St. Martin's Press, 1998).

feminism,[24] which according to her encompasses Islamic women activists. She says:

> I understand and use feminism as an individual or collective awareness that women have been and continue to be oppressed in diverse ways and for diverse reasons, and attempts towards liberation from this oppression involving a more equitable society with improved relations between women and men.[25]

She presents "Islamist feminists" as a group that has evolved through different generations, beginning with Zeinab al-Ghazali, to Safinaz Qazim and lastly to Heba Raouf Ezzat. She understands these women to be feminists because she believes that their activism is influenced by an awareness of gender injustice and a desire to redress this imbalance using an Islamic paradigm. Her explorations have centered on the documentation of women's activism within the relations of power and resistance that link Islamisms, feminisms, and the state. Karam traces the relationship between Islamic feminists and Islamist movements, and describes their inclination to be political in nature. According to Karam, Islamist power in society relies upon exclusionary/inclusionary boundaries that they control from a privileged position of religious superiority and hence legitimacy against the state. Karam sees the struggle for legitimacy between the state and Islamist groups to lie in the question of "who is the better Muslim." The emphasis on the public demonstration of religious zeal determines many complex outcomes in which women are also caught up. Azza Karam's work is important to my research, which intends to probe deeper into the impact of Islamic activism on women's empowerment in Egypt. While Karam confines her attention to Islamic feminists who engage in political activities that directly oppose the state, my focus will expand on hers in that I focus on Islamic women activists who enjoin an Islamic paradigm but who do not necessarily participate politically as feminist or otherwise, though they may display alternative forms of activism that they undertake to fulfill their religious aspirations.

The subject of power has also concerned Fatima Mernissi, who claims that "Islam is definitely one of the most political forces for power around

[24] Such definitions challenge universal interpretations and stresses particularity.
[25] Karam, p. 5.

the globe.... Islam makes sense because it speaks about power and self empowerment."[26] To Mernissi, power cannot be enjoined with spirituality, and she adds that this worldly self-enhancement of Islamic activist groups undermines that notion. Saba Mahmood writes about the spiritual nature of the women's Islamic movement in Cairo, presenting a unique alternative to examining Islamic women of what she calls, "the mosque movement" in Egypt.[27] In her treatment of this issue she builds upon the notion of embodied discipline. Mahmood dispenses with much of what recent literature has had to say on women's Islamic feminism, choosing instead to understand these Islamic women by relying on their own views of what they are hoping to accomplish and how they intend to accomplish it. Her research centers on an ethnographic study of the women who seek to perfect their spiritual relationship with God by refining their pious selves through the embodiment of ritual. I find Mahmood's work to be very helpful to my research because she is attempting, as I am, to avoid the constrictions posed by feminist theory and liberal modernist views in analyzing these women's experiences. Mahmood predominantly relies on Foucault's notion of the construction of the subject through relations of power and subjection, and employs Judith Butler's theory on subjection and power to build upon Foucault. In the case of this research, however, I diverge from Mahmood in that her focus is on interpreting the notion of the creation of piety through disciplined ritual. Instead, my intent is to interpret the ways in which activism and the search for religious spirituality impact women, as both contribute to Islamic women's experiences today. I therefore conducted my research in Islamic PVOs as well as mosques in order to gain a wider perspective of the scope of contemporary Islamic activism. Moreover, I chose to enjoin a combination of approaches that emphasize the social and cultural as well as the pschodynamic, with a strong emphasis on the historical experience as central to the understanding of women in Egypt today. In spite of these differences, Mahmood's contribution to this study remains of great value.

[26] Fatima Mernissi, "Muslim Women and Fundamentalism" in Suha Sabbagh, *Arab Women: Between Defiance and Restraint* (New York: Olive Branch Press, 1996) p. 163.
[27] Saba Mahmood, *Women's Piety and Embodied Discipline: The Islamic Resurgence in Contemporary Egypt* (USA: UMI, 1998).

A number of specialists on the Middle East such as Margot Badran find that only secular feminists have influenced patriarchal relations and challenged male supremacy in society because, in her opinion, Islamic feminists have merely repeated gendered male discourse.[28] On the other hand, in *Modernizing Women*,[29] Valentine Moghadam interprets the effects that the resurgence in the Islamist movement has had on women. While she views these women as agents of change, she points to the inherent difficulties in using the label "Islamic Feminism" for Islamic women who refuse to be identified with feminism owing to its Western connotations and their need to distance themselves from feminism in order to avoid losing credibility with Islamists. Moghadam, however, does not expound further on the issue, and Margot Badran prefers to use the term "gender activists" to describe them while reiterating that, with reservations, they "may be provisionally labeled "Islamic Feminists.""[30] The implication in both studies seems to be that Islamic women's activism assumes feminist goals mainly in the area of gender, hence the use of the term "gender activists" since, in principle, only feminists call for gender equality as a goal.

Other scholars categorize Islamic women activists according to their views on gender that, these studies maintain, reflect the nature of the diversity among Islamic women in Egypt today. Sherifa Zuhur, who studied Islamic women in Egypt, emphasizes the diversity of Islamic women's groups based on their discourses.[31] Though she criticizes the view that regards Western feminism as a universal paradigm and sees it as a detriment to non-white women and women of the Third World, Zuhur nevertheless categorizes Islamic feminists into liberal Islamist feminist, moderate Islamists womanism and conservative Islamist position. She notes that Islamic women accept neither gender models propagated by the state in schools and in the media, nor those lived in Western societies. They also

[28] Margot Badran, "Competing Agenda: Feminists, Islam and the State in 19th and 20th Century Egypt," in Deniz Kandiyoti ed., *Women, Islam and the State* (Hampshire: Macmillan Press Ltd., 1991) pp. 201-237.
[29] Valentine Moghadam, *Modernizing Women: Gender and Social Change in the Middle East* (Cairo: American University in Cairo Press, 1993).
[30] Margot Badran, *Feminists, Islam, and Nation: Gender and the Making of Modern Egypt* (Cairo: American University in Cairo Press, 1996).
[31] Sherifa Zuhur, "Women Can Embrace Islamic Gender Roles," in David Bender & Bruno Leone, eds., *Islam: Opposing Viewpoints* (San Diego: Greenhaven Press, 1995) pp. 89-99.

reject the model of the active elitist Egyptian woman. Zuhur goes on to define Islamic activist women as "womanist" in that they share similar goals with womanist trends. Womanism, she explains, accepts the complementarity of the sexes and motherhood and defines the roles of women in clear terms. Haddad and Smith, on the other hand, describe Islamic women activists as:

> Islamist women who do participate actively in promoting the rights and opportunities that they believe Islam truly accords them generally do so out of a position that speaks from within their own culture, consciously avoiding articulation that represents foreign ideologies or perspectives that seem to reflect Western feminism.[32]

Haddad and Smith, like Zuhur, advocate the application of the term "womanist" to describe these women's group. While calling for the protection of just laws so they can fulfill their potential and assume leadership roles in society, most Islamic women activists see that the nature of the combination between the legal system and Islamic ideology has not been advantageous for women. In Egypt, Zuhur maintains that all the women she interviewed were convinced that Islam is a not anti-women. She makes an important point in her work when she explains that the various groups of Islamic women who diverge on issues of gender present varying viewpoints about women's roles in society. The more conservative factions promote women's domestic roles and denounce women's public participation on the grounds that interactions with men are dangerous to the stability of society. What Zuhur calls a more "moderate" or "liberal" group would see that a woman should work so long as her family and home do not suffer therefore.[33]

Scholarly work concerned with an Islamic feminism has been preoccupied with the historical examination of Islamic ideology and its compatibility, or lack of, with a feminist agenda. Less has addressed the impact of women's contemporary Islamic ideology on women's self-empowerment. In fact, most studies have looked upon the increasing

[32] Yvonne Yazbeck Haddad and Jane I. Smith, "Women in Islam: 'The Mother of All Battles'" in Sabbagh, p. 147.
[33] Ibid, p. 94.

Islamization of Egyptian society as an alarming phenomenon[34] and thus feared its negative impact on women's issues. "Islamisms," in short, create visions of fundamentalists, the veil and the swarming numbers of unsuspecting men and women adherents who unknowingly add sustenance to extremist Islamic currents that seek to undermine the status quo and replace it with a repressive and backward regime. Islamic discourse dealing with social change and *shari'a* is dismissed as degenerating, a return to early Islamic teachings bearing little relevance to the needed modernizing development of Egyptian life. In introducing a novel Islamic paradigm from whence to debate issues pertaining to women's roles, once exclusively reserved for a male religious elite, Islamic women scholars create a new battleground on which to fight the same war alongside secularist feminists. However, the literature produced from anthropological and sociological studies about women in the region has paid less than adequate attention to their project. Whereas some recent research addresses the subject of women's involvement in a feminism based on Muslim text, scholars do not elucidate on the processes of empowerment that are engendered by an Islamic women's activism. I intend to rectify this lacuna in the writings on Islamic feminists by attempting to understand the impact of Islamic women's activism on women's empowerment in Egypt.

With few exceptions, only a limited number of studies have dealt with the challenging notion of an Islamic empowerment for women. It may be difficult for some writers to describe, let alone to perceive women who are veiled as empowered. It has indeed been a challenge to writers about the Middle East to recount the histories of women there without shaking the unmistakable hold on their imagination of the oppressed "Muslim woman."[35] Moreover, Islamic women activists pose a serious methodological challenge for scholars who study women and feminism in that they do not subscribe to a feminist agenda.[36] Consequently, the work of Islamic women has largely been overlooked when discussing women's activism. It is the intention of this project to bring forth the women who

[34] Eberhard Kienle, "More than a Response to Islamism: The Political Deliberalization of Egypt in the 1990s," *Middle East Journal*, vol. 52:2, Spring 1998. And others.
[35] Lazrag.
[36] Moghadam, pp. 160, 165-167.

have labored to create a long suppressed synthesis between. Islamist ideology and women's needs. The impact of their vision on women's empowerment will be examined in the following study.

Writers such as Marnia Lazrag[37] and Ellen Fleischmann[38] find that Islam is still being presented in teleological reasoning as the ultimate explanation for a number of issues, which detracts from the real focus especially when dealing with women. Other factors that contribute to women's exclusion from positions of power in society include access to resources, state ideology, class, and local development.[39] This study follows their reasoning by showing how the Islamic women's project attempts to reveal that the true Islam is not the underlying cause that undermines women in Arab Muslim society. It is therefore unsound to assume that Islam will empower women in every walk of life or that it is the only answer to women's problems. What I am advocating in this study, however, is that Islamic women's activism impacts women in ways that will enable them to be aware of their power and their potential to implement the kind of changes they foresee for women. While Islam is not the focus of this study, the outcome of employing Islam as a discourse that benefits women is, however. Today Islam, like feminism, is employed as a framework for women who struggle to seek improvements in society as means of gaining higher levels of religiosity and proximity to God. This research investigates its impact.

The following study reveals as well the potential of an Islamic pro-women approach to address issues of empowerment from the grassroots level to a broader range of women, where secular attempts have met with limited results owing to their top-down nature. The interpretation and application of Islamic teachings and *shari'a* law assumes a significant position in the Egyptian debate over Personal Status Laws, which affect women of all creeds in the country. The findings from this research will help shed some light on the projected future trends and directions on the platform of women's activism at a time in Egypt when these rights are being

[37] Lazrag.
[38] Ellen Fleischmann, "The Other Awakening: The Emergence of Women's Movements in the Modern Middle East, 1900-1940," in M. Meriwether and Judith Tucker, eds., *A Social History of Women and Gender in the Modern Middle East* (Boulder: Westview Press, 1999) pp. 89-123.
[39] Moghadam, p. 14.

continuously undermined by growing extremist trends and complacent state policies. The study intends also to broaden our understanding of Islamic discourse on women in Egypt today by investigating the ways in which Islam has provided the stimulus for women to claim a public role in the articulation as well as application of Islamic discourse and debate. It will contribute to the body of literature on women's movements in Egypt in recent decades by providing an analysis of the impact of contemporary Islamic women's activism on women's empowerment, and offers an alternative framework to prevalent views that attempt to interpret Islamic women's activism from a liberal feminist perspective. This study proposes an indigenous interpretation based on these women's own notions of empowerment. By situating Islamic women's activism among other kinds of activism, the study will allow its impact on women in Egypt to be better understood.

The research will show how Islamic activist women are able to overcome conditions that undermine women such as illiteracy, inefficient health care and ignorance of rights in Islam and, more importantly, create a women-centered religious space by which to transform male-headed pulpits into ones from whence women's activism can resound to address women's interests. Islamic women inform people in powered positions in government of women's concerns, which they discuss on a par with male Islamists as Islamism gains more public space in Egypt than has been recorded before. They conduct forums of dialogue to create awareness and to allow for exchanging ideas. They organize training sessions, carry out community projects, and teach hundreds of under-privileged women skills necessary for employment and economic gain. In major cities in Egypt today, the phenomenon of educated women who are emerging as *da'iyat* (women preachers; sing. *da'iyah*) for a female audience has attracted much media attention. Certified to preach from *wizarat al-awqaf* (Ministry of Religious Endowments) and armed with a good background in Islamic teaching, they are attracting thousands of city women around them to hear their sermons. Many of these *da'iyat* do not adopt feminism in their outlook, nor do they have a particular interest in addressing issues of gender equality. Yet I will show how their discourse, which is aimed at perfecting the self through enhancing its relationship to God, also provides empowerment to women who are educated and of various socioeconomic and educational levels, and

encourages them to find in Islam a frame of reference and an anchor from the problems and concerns of an increasingly challenging world. It is my view that these women preachers hold the key to help link the discourse of Islamic women scholars such as Heba Raouf Ezzat to that of ordinary women in Egypt.

The scholarly activism of Egyptian Islamic women intellectuals such as Heba Raouf Ezzat and Omaima Abu Bakr, among others, have created a new wave in the Islamic women's debate on the position of women in Islam. Ezzat and Abu Bakr's informed discourse might act as a catalyst for Islamic women activists and challenge them to explore wider circles of debate and *ijtihad*. They provide a good perspective on the public debate on women and their position in the Muslim Middle East from within an Islamic perspective. Their goals and aspirations for women will help shed light on Islamic women's discourse on women's empowerment. These women scholars are capable of demonstrating their right to participate in the dominant discourses in their society and to contest male exclusivity on the religious forum based on knowledge of the Islamic texts. Yet their discourse is encapsulated in a scholarly context and has not been able to reach the wider circles of Islamic women who work in the field. It is my contention that women preachers may serve to make the connection between theory and practice in the area of women rights and the emerging discourse on women's political role in Islam.

In this chapter, I have focused on the research process that has formed the backbone of this study, which addresses the subject of Islamic women's activism in the Middle East. I have identified my research goals, described my entry into the field and reviewed the body of literature and the approaches it takes toward interpreting Islamic women's activism as a brand of feminism, as a bid for power, as a pious movement, and as a movement for social change. The next chapter traces the historical, social and cultural developments that have contributed to the emergence of an Islamic movement for women in Egypt. It also presents the case of Iran, where women have gained much attention as Islamic feminists in the debate over the reinterpretation of Islamic doctrine. This historical examination will contribute to my analytical framework by providing context to my argument. Chapter Three offers an explanation of the methodological tools used in collecting data for my study of Islamic women activists in Egypt.

The ethnographic material demonstrates the links to the theoretical postulations that I present in Chapter Four by showing why the paradigms of liberal feminism are not adequate in explaining the particular brand of activism demonstrated by Islamic women. In this chapter, my examination of the theoretical frameworks that address notions of subject formation in Middle Eastern and Western societies takes place. Chapter Five concludes this research and hints at the trends that an Islamic women's movement may take.

CHAPTER TWO

ISLAMISM AND WOMEN'S MOVEMENT: UNDERLYING THEMES FROM THE 1800s TO THE PRESENT

Studies addressing Middle Eastern women propose that a true understanding of women's position and activism in Muslim societies cannot be reached by focusing solely on Islamic ideology or socioeconomic processes or by employing universalistic feminist theories. Rather, a thorough analysis of women's activism in Muslim societies must begin by taking account of the political projects of contemporary states and their historical developments.[1] To lay out the groundwork for such an analysis the following pages will look at the historical specificity of Islamic women's activism in Egypt, placing such projects, led by men and women, within their historical, social and political contexts. Rather than presenting women's activism as stages in a counter-patriarchal feminist movement placed on an evaluative/evolutionary scale from traditional to modern, their activism will be contextualized within the historical development of anti-colonial nationalism, state building projects and Islamism. The chapter will conclude with a brief look at the Iranian model of Islamic women's activism to draw upon their experiences in their search for participation in the new Islamic republic.

The issuing conflicting agendas over the "woman's question" in Egypt may be arranged within four historical periods: the modern state building of the 1800s-1922, the liberal projects of reform of 1923-1952, revolution and nation building of 1952-1970s and, lastly, the period of *infitah* (open door policy), capitalism and Islamist resurgence of the 1970s to the present.[2]

[1] Deniz Kandiyoti, *Women, Islam and the State* (Hampshire: Macmillan Press Limited, 1991) p. 2.
[2] Badran in Kandiyoti, p. 203.

Modern State Building

Since antiquity women have demonstrated their claims on the public sphere, though such endeavors have been sporadic and inconsistent. After long periods of foreign occupation, the advent of the Mohamed Ali period brought yet more contact with foreign powers, which characterized the emergence of the political and economic processes applied by the Pasha. Private ownership replaced state ownership as Egypt was thrust into a new market economy. The state sought to attract women into the emerging economic and technological reforms, and thus influenced women's family ties and men's authority over them. Women found themselves torn between their roles as citizens in a new nation state and their positions as direct subjects of al-Azhar religious establishment, which now governed their personal status laws. Margot Badran surmises that this dichotomy was never a precise one, and has created tension and contradictions from which women have suffered to this day. Underlying these conflicts and competing interests, a traditional patriarchal system continued to wield control over women.[3] The intricacies of the relationship between these players have collectively influenced the outcome for women's activism.

With the proliferation of upper-class agrarian capitalist landowners, the careers of female farmers and women merchants came to a swift termination, thus effectively relegating them to the household and terminating their livelihoods. Moreover, some studies show that the enforcement of male conservative measures over women at that time was an attempt at intensifying cultural identity as a reaction to increased European influence. Some authors reason that the middle-class feminist movement that arose in the early twentieth century was due partly to these types of modern developments.[4] The adoption of European cultural norms signaled a shift from Ottoman status symbols to a Western frame of reference in matters from education, manners, dress, and social etiquette to a reconsideration of gender roles and expectations. Examining a cross section of class, J.R. Cole explains that while the upper and middle classes in Egypt were more likely to adopt Western traditions as a reflection of their

[3] Ibid, p. 201.
[4] Juan Ricardo Cole, "Feminism, Class, And Islam in Turn of the Century Egypt," *International Journal of Middle East Studies*, vol. 13, 1981, pp. 387-407.

economic gains under a capitalist system, the lower petite bourgeoisie (*'ulama*, bazaar keepers, and artisans) were resistant to Westernization. This was not only because of the daunting economic and intellectual effort such a transformation entailed, but also because for them Westernization did not pose an opportunity for economic gain the way it did to the upper classes. Instead, the majority of Egyptians from this social stratum claimed a course of authenticity and Islamism derived from practices of the past Ottoman upper class, which valued such practices as the segregation of women.[5] The ideological divide on women's place in Egyptian society towards the end of the nineteenth century centered on a modern liberal emancipation for the upper classes on one hand and an Islamically informed discourse on women on the other.

There were those intellectual reformers whose work attempted to bridge such divides. The Islamic intellectual Mohamed Abduh was one such man. Abduh's work centered on creating a progressive Islam that was compatible with modernity. He argued for his views using *ijtihad*, and called for the right to the reinterpretation of the Qur'an according to the needs of the time. Abduh supported education for women as well as legal reforms of traditions that were harmful to women and the family such as polygyny. Mohamed Abduh's views had a deep effect on the work of another man, the infamous Qasim Amin, whose work on reform stirred up controversies that rage until this day.[6]

Amin was an upper-class Egyptian who was educated in France. His books, such as *The Liberation of Women* and *The New Woman*, exemplify his logic, which centered on the idea that Egypt's development was contingent on women's emancipation. Although he often referred to Islam in his work his views were not derived from an Islamic perspective, relying instead on a modern liberal discourse of capitalism. Amin's writings display a strong upper-class bias; he totally denigrates the lower classes, whom he bitterly describes almost as horrific beings. Egyptian women do not fare any better in his treatment. However, Amin does not forget to praise and revere the West and especially the British. While Amin called for reforms for

[5] Ibid.
[6] Lila Abu-Lughod, "The Marriage of Feminism and Islamism: Selective Repudiation as a Dynamics of Post-colonial Cultural Politics," in Lila Abu-Lughod, *Remaking Women* (Cairo: American University in Cairo Press, 1998).

women such as access to higher education, opportunities to enter into the labor market, and the need to protect the family from a random practice of divorce, he was not concerned with any of their political rights. Of all his goals for women, however, the one that received the severest criticism was his demand that they remove the veil. Tal'at Harb, who was one of Amin's main opposers, echoed the *'ulama's* estrangement with his vision of reform and emphasized the need to preserve the people's dignity by protecting women and keeping them in the homes. Leila Ahmed, who analyses Amin's life's work, concludes that although he hoped to improve conditions for his compatriots, in the case of women his search to apply standards that were too external to Egyptian society and were not interchangeable did more harm than good. His concerns were directed at satisfying the needs of the growing upper class.[7] Not only did Amin deepen the rift between class ideology on the "woman question" in Egypt, but he also emphasized women as the demarcators not only of class differences, but also as symbols of the nation state against the West. This further alienated the growing Islamized petite bourgeoisie.

Furthermore, the work of Lila Abu-Lughod shows that although his aims were directed inwards, the benefits of Amin's reforms were directed outwards at the British by deepening the transformation of Egyptian society into mere repositories of European values, products and government. They were the beneficiaries of Amin's hopes for Egyptian men and women. Abu-Lughod's analyses reveals that Amin proposed lofty goals for women's social expectations that undermined rather than motivated a development in women's status in the country. [8] This was because in imposing Western criteria for women's emancipation he directed Egyptian feminist women to look elsewhere than in their own environments for models of emancipation.

Meanwhile, women in the upper and middle class articulated for the first time a feminist awareness with a nationalist fervor that was directed at the British occupation of Egypt. Women like Malak Hefni Nasif and Nabawiyya Musa set the tone for women's movement in the future by outlining the need for education and public places for worship as their agenda of the time. However, it was the advent of the revolution of 1919

[7] Leila Ahmed, *Women and Gender in Islam: Historical Roots of a Modern Debate* (Cairo: American University in Cairo Press, 1993) pp. 155-165.
[8] Abu-Lughod.

that was a turning point for women with feminist agendas who, moved by nationalistic spirit, joined the party of the Wafd in their quest for liberty from colonial rule.

Liberal Projects of Reform

Despite their efforts, however, women were soon to be disappointed. Immediately after the liberal Wafd came to power they completely disregarded their promises to women, granting suffrage as a privilege to men alone in the 1923 Constitution. This undermined liberal principles, which in theory called for equal political representation for all citizens. As Egyptian liberalism was partly derived from early European liberalism, it succumbed to the laws of patriarchy maintaining inequality between men and women that, as the work of Carol Pateman on classical liberalism reveals, was already biased against women.[9] As the liberalist tradition constructed clearly separated spheres between the private and the public, it reinforced the exclusion of women from the public sphere, this time justifying their marginalization on philosophical and administrative grounds.[10] Undeterred by their alienation from the liberalist government, which fell short of allowing them political space, women's activism took an alternative form of political representation. They created an independently organized movement that articulated their own separate goals and acquired its own leadership. Thus they formed the Egyptian Feminist Union (EFU), headed by Huda Sha'rawi. Under her leadership they now used the French term *"feministe"* to describe their political activism, removed the veil and built their agenda on those originally laid out by former feminists. Feminists placed more emphasis on women's need for education and job opportunities, as well as the need to reform the Personal Status Law, which they argued was unfair to women.

While elitist women agitated for their rights, bolstered by their new founded union and protected by their status and ties to government, another movement with different social ties began to take shape. The Muslim Brotherhood was established in 1928 by Hassan al-Banna with great appeal

[9] Carol Pateman, *The Sexual Contract* (Oxford: Polity Press, 1988).
[10] Selma Botman, *Engendering Citizenship in Egypt: The History and Society of the Modern Middle East* (New York: Columbia University Press, 1999) p. 23.

to the lower strata of the society, many of whom, isolated from discourses informed by Westernization, marginalized by a capitalist market economy, and excluded from social transformations, increasingly sought solace in an indigenous movement that called for an Islamic state in Egypt. In contrast to the perceived corruption of the upper class, morality was stressed and Islamist[11] values and authenticity were reinforced. The Brotherhood concluded debates on gender with swift finality. Their teachings maintained that the patriarchal system is the ideal system for the Muslim family where gender differences are clearly delineated, and men have authority over women. Propagating these views, but not exactly adopting them in her own life, a female figure emerged from the ranks of the Islamists.

Zeinab al-Ghazali, the daughter of a cotton merchant from a well-to-do, conservative family, who had previously espoused feminism as a member of the EFU, decided to reorient her goals and join the growing Islamist movement. Al-Ghazali was attending religious lessons at al-Azhar in 1936 when she decided to start an organization of her own, the Muslim Women's Society. She maintained her ties with the EFU, however, and later joined forces with them for the cause of nationalist activism. With a reputation as a "soldier of God" among Islamist women and men, al-Ghazali had a tremendous following. Her career focused on establishing the framework for the activism of the Islamist movement in Egypt. She is said to have regrouped the Brotherhood after government imprisonment had fragmented their ranks. Aside from her administrative responsibilities, al-Ghazali, at the age of eighty-three, today takes pride in mentioning that she is still involved in *da'wa* (lit. invitation to Islam) through teaching religious lessons to her Muslim sisters.[12] She views *da'wa* as such an important duty of all Muslims that she developed special instructions on its artistic principles.

[11] I will follow Najib Ghadbian's, "'Islamist' denotes *Islamiyyun*, is what people belonging to Islamist movements call themselves... The majority of the Arab world is Muslim, while only those with ideologies that call for the implementation of Islam in the public as well as private realms are Islamists." Najib Ghadbian, *Democratization and the Islamic Challenge in the Arab World* (Boulder: Westview Press, 1997) p. 7.

[11] In this sense my use of the term "Islamic" (in defining contemporary activist women) does not distinguish between the terms "Muslim" and "Islamist" which some scholars see necessary.

[12] Karam, p. 208.

Women's role as mothers and tutors to the future generations is central to al-Ghazali's discourse. Accordingly, she maintains that there is no women's issue in Islam. She finds that Islam views women and men in a unified sense with clearly defined roles for each. To her, while women are the "indirect builders," the building[13] is entrusted to men. Al-Ghazali attributes the debate over women's issues and rights to be caused by the disruptive forces of the West, which she describes as a conspiracy. The West, she claims, robbed women of their right to have children. According to her, Western women " …became a distortion and a commodity available for the lust of the wolves." [14] This kind of criticism of Western women continues to be employed in Islamist discussions about women's roles in society. Islamic women's chastity is seen as the desired opposite of a demeaning Western freedom for women.

Two significant observations have been made by Azza Karam in her examination of al-Ghazali's life. The first is a shift towards the latter part of her career from singularly perceiving women as mothers and wives to seeing women as individuals with the freedom to choose what suits them, whether it be a career outside the home or a career inside it. The second is the fact that al-Ghazali may not follow what she preaches, since she herself divorced her husband when she found that he impeded her Islamic mission.[15] Al-Ghazali's engagement with gender roles is thus one that in theory yields to religious teaching while in practice succumbing to practicality.

Al-Ghazali's contemporaries included feminist Doria Shafik. Like Ghazali, Shafik came from a middle-class family, but used a different ideology and took an alternative path altogether to seek women's empowerment in society. Shafik was affiliated to the EFU when she traveled to France to receive her doctoral degree. Shafik's biography describes her return to Egypt as full of promise and enthusiasm about assuming a position of leadership, and then the let-down that followed that explains much of her later dissatisfaction as a revolutionary crusade against

[13] I believe, "builders" here denotes builders of society, i.e. the executives of plans.
[14] Karam, p. 210.
[15] Zeinab Al-Ghazali, *Ayyam Min Hayaty* (Days From My Life) (Cairo: Dar Al Shuruq, 1982).

the state.[16] Her views on feminism were not only beyond her time, but sadly also beyond her place in that they invited ridicule from the public and, unfortunately, lost her credibility with many of her compatriots. Shafik's agenda was not an unreasonable one; she called for women's right to vote and to run for parliament, causes for which she sacrificed much, staging hunger strikes and demonstrations. Although she succeeded in attracting much attention for her cause, Shafik failed to realize her objectives because she misread the political and social climate of the time.

Revolution and Nation Building

The period of the revolution witnessed a visible shift in political life, which at this time had become collectively nationalist to the exclusion of all other political views, including feminism. The new socialist regime adopted policies of reform that did not single out women as repositories of special policies. On the contrary, the wave of education, health and social welfare was indiscriminately provided to the entire population. As equal citizens to men, women gained the vote, and were promoted to positions of leadership in the country. The state went on to establish a policy of "State Feminism," by which many women were mobilized.[17] While a remarkable improvement took place in women's public role, in the realm of the family, gender roles were not ideologically challenged as the regime refused to amend the Personal Status Laws. Without this significant element, a complete transformation of Egyptian women could not take place.

The aftermath of the defeat of the 1967 Arab-Israeli war is often singled out as the point in Egyptian history that witnessed the first emergence of Islam as a political force. Islam resurfaced as a source of solace and as a reference for ethical and moral questions in society, thus signaling its gradual transformation from the private to the public sphere.[18] Islamists became the single most politically marginalized group in Egyptian

[16] Cynthia Nelson, "The Voices of Doria Shafik: Feminist Consciousness in Egypt from 1940-1960," *Feminist Issues*, vol. 6:2, fall 1986, pp. 15-31.

[17] Mervat Hatem, "Economic and Political Liberation in Egypt and the Demise of State Feminism," *International Journal of Middle East Studies*, vol. 24, 1992, pp. 231-51.

[18] Al-Ahram Center for Political and Strategic Studies, *The State of Religion in Egypt Report* (Cairo: Al-Ahram Foundation, 1995).

society during the Nasserist regime. An alleged attempt on Nasser's life in the beginning of his presidency sealed their fate and eliminated any influence they may have had over the population. As the Islamists were severely punished, their political and organizational identities crystallized, producing more intellectuals and writers than militants and terrorists. Among the Islamist women who emerged at that time is Safinaz Qazim, who represents a more contemporary generation of Islamist women. In her fifties today, she is a child of the revolution, yet also its victim. Qazim, like al-Ghazali, tasted imprisonment under both Nasser and Sadat. Her inclination to shun political life today is therefore not surprising. Qazim is a dynamic, vivacious and talented woman. Many of her acquaintances know her as an artist; one claims: "Her (singing) voice, was even more beautiful than Umm Kulthoum." Others have commented on her poetry and writing, which displays a sophistication and evocativeness comparable only to the best in the field. Qazim's greatest passion is to dedicate herself to the worship God and to study Islam. She is highly vocal about gender issues and focuses on women's rights in Islam, which, she believes, ensures women's liberation in society:

> I am all for women's liberation... In my view, a woman's commitment to *shari'a* is the highest degree of liberation a women can achieve. It is true that many of the rights which *shari'a* grants to women are violated, but it is also true that women should strive to gain those rights. In doing so, women should seek those rights as human beings, avoiding the sexist perspective.[19]

Women had to resign themselves, however, to the fall of the socialist system and a shift from 'state sponsored feminism' to a period of severe socioeconomic dislocation in the following regime.

The Period of *Infitah*, Capitalism and Islamist Resurgence

Sadat sought to diffuse the previous regime's power by relying on Islamic groups to rally public sentiment. To appease the Islamists, he not only released those imprisoned by the Nasserist regime but also maintained a

[19] As quoted by Karam, p. 219.

complacent policy when it came to issues of women and the family.[20] During this period, culture and society were deeply influenced by what Soha Abdel-Kader describes as "a simultaneous movement of people."[21] As foreigners moved in searching for new investments, large numbers of Egyptian men moved out seeking labor opportunities and economic gain. The effects on women were profound. Many of the men who migrated were of the lower to the middle class range, who were characteristically young and just starting families. Their wives, newly married with young children, were left to take charge of the household. The rapid economic gain of these families propelled them socially upwards, thus changing their consumption patterns and increasing their materialism. Westernization, according to Abdel-Kader, was sweeping across the upper classes, and the upwardly mobile middle classes hesitated in a stage of momentary confusion between emulating the upper classes or "protecting" their Egyptianess against the dangerous trends that challenged its authenticity. The resurgence of what came to be called "Islamic fundamentalism" accelerated this shift of the middle classes inwards. Many Egyptians became disillusioned with the period of *infitah*, seeing it as another economic endeavor doomed to failure, and blamed Westernization for the deteriorating conditions in society. In the absence of another discourse of hope many people turned to the only strong promise and coherent plan for a better future, Islamism. Tension rose as Sadat's wife, Jihan, took on a Westernized, liberated and non-Islamic model of ideal womanhood, a fact that, as mentioned in the trial of the Jihad assasinators of Sadat, was one of the main reasons that signaled the urgency of their mission.[22] As the lofty economic dreams that Sadat had promised the country toppled along with his reforms, Islamists elaborated on visions of an Islamic society in which the family played central stage as their answer to Egypt's woes. "*Al-Islam howa al-hal*" (Islam is the solution) became their battle cry. With the close of the 1980s, and following the Islamist assassination of Sadat, another wheel was set in motion taking

[20] Mervat Hatem, "The Enduring Alliance of Nationalism and Patriarchy in Muslim Personal Status Law: The Case of Modern Egypt," *Feminist Issues*, vol. 6:1, 1986, pp. 19-43.
[21] Soha Abdel-Kader, *Egyptian Women in a Changing Society* (Boulder: Lynne Rienner Publishers, 1987) p. 125.
[22] Nemat Guenena, "*The 'Jihad': An Islamic Alternative in Egypt*," *Cairo Papers In Social Science*, vol. 9, monograph 2, summer 1986.

Egyptian society into closer proximity to Islamism and increased public demonstrations of faith.

An Islamic Women's Movement

With the advent of the Mubarak regime Islamism resurfaced with stronger intensity as a popular discourse and an organized system, which built upon its old machinery that was set in place in the 1970s and 80s. The Islamic network of social services included Islamic cultural centers, health units, schools and widely spread systems of social welfare, which after many years proved far more reliable than the retreating support of the state. For a short while it appeared as if the economy was stable, and the administration had good intentions for a new era. However, people were soon disappointed as Egypt sank more and more into economic decline and corruption. This, in addition to increasing public demonstrations of wealth, stirred up old resentments fueled by extreme discrepancies in standards of living and a decline in services provided by the state in vital areas such as education and health. The rise of unemployment coupled with the decline of opportunities for labor in Arab countries put an end to a viable option for unemployed graduates. A general perception of dissatisfaction with the conditions into which the country fell is illustrated in the popular book by Galal Amin, *What Has Happened to the Egyptians*? whose title echoed what was on many people's minds. This book depicts a picture of a people in decline, far removed from the image of the proud, nationalist citizens of not so long ago. The public obsession with Western values, food and fashions echoed the early 1920s when upper and middle-class Egyptians adopted Western status symbols as markers of social mobility. However, in today's Egypt different elements are at play. The Egyptian middle class in the 1920s sought and found economic gain from a booming economy. The present middle class, although more educated and qualified in the job market, is barely able to sustain itself due to lack of employment and opportunities to generate income. Egyptian society, writes Amin, has been subjected to wider class displacements as the influx of laborers from the countryside into the city creates squatters that threaten to cave in and give way after the building boom of the 1980s. A symptom of these problems is violence, which is on the rise. Focusing on the present situation in Egypt, Islamists

reason in their discourse that the underlying explanation for this decline is that Muslims no longer follow the true Islam.[23]

Modern reforms proposed by Egyptian leaders and statesmen have proved their inadequacy. They were posited in direct opposition to tradition, which they represented as Islamism in their modernist discourses. As these projects failed to uphold their promised agenda they are challenged by indigenous Islamic alternatives, which are still untried. Though the Islamic revival was instigated by male leadership, the popular movement observed in Cairo today is spearheaded by Islamic women. Islamic women lead a popular religious movement that has gained impetus in the last two decades in Egypt. In addressing itself to women, it aims at the Islamization of Egyptian society and the replacement of alien corrupt and immoral practices with Islamic values and norms. Islamists regard this aim as the only way to rise above the present state of what they describe as chaos in society.

> It is the vastness of the territory covered by Islam that lends to the dramatic resurgence of calls for Islam as the solution to worldly societal issues. Whether the problem is Egypt's defeat by Israel in 1967 or the lack of affordable housing in 1998, activists promote Islam as a political, social, economical and spiritual embodiment of the "solution." Certainly, argue the Islamists, the failure of both socialism and capitalism to address Egypt's (and the entire Muslim world's) grievances indicates that a return to Islam at both the individual and the collective levels is imperative to the success of the nation.[24]

Statistics show that private mosques and Islamic NGOs have rapidly increased in recent years.[25] The phenomenon of veiling and the adoption of the Islamic dress code prevail among the majority of urban women. Many women find their calling in an Islamic ideology that promises not only a worldly status of respectability, but an eternal value to their good deeds in heaven. Islamic activism is to many women the most easily accessible social means to improve themselves, enhance their social status and instate improvements in Egyptian society. Aside from nationalist activism against the British, there is not a single cause in Egyptian history around which

[23] Galal Amin, *Matha Hadath Lil Masryyin? (What Has Happened to the Egyptian?)* (Cairo: Dar El Hilal, 1997).
[24] Denis Sullivan and Sana Abed-Kotb, *Islam in Contemporary Egypt: Civil Society vs. the State* (Boulder: Lynne Riener Publishers) p. 124.
[25] Ibid.

women have rallied with such fervor. Feminist goals and leftist causes never appealed so intensely to women, nor did those movements, as we have seen, ever make themselves accessible for women from all classes and socioeconomic backgrounds, as Islamism succeeds in doing today. Furthermore, the pedagogical principles upon which Islamic activism is predicated welcomes novices and those women who do not necessarily represent religious material. The recent veiling of famous actresses in Egypt is one example. In short, Islamism acts as an undiscriminating bridge between the spiritual and the social for women, where many Muslim women of all backgrounds find a place.

Islamic Women's Scholarship Activism

Islamic women activists pursue religious disciplines in order to perfect their own behavior and to bring themselves closer to God. Many develop an empowerment that evolves out of processes of religious self-discipline by which some Islamic women attain positions of power and influence in society. Another group of Muslim women, who are slightly apart from the ranks of the Islamic women activists, are the Islamic scholars who labor to provide Egyptian Islamism with a women-centered reinterpretation of the Qur'anic texts. Islamic women's scholarship today navigates a path within the Islamic movement that is concerned with women's role in Islam. These Islamic women scholars reach an empowerment predicated upon knowledge, one that creates a new framework from whence to contest a traditionally sanctioned male dominance over women, and work to shake the foundation of male hegemony over the Islamic texts. As Islamic women scholars use strategies common to discourses of Islamism, of simultaneous rejection and engagement with Western modernity, they share in the discursive power of Islamist leaders. Nevertheless, they manage to maintain integrity towards their own mission to restore to women their rights in Islam. Many of their goals may appear modernist and even secular feminist, yet the aspect of authenticity remains central as a guiding framework. They insist on political participation for women as a legislated right by Islam.

Among Islamic women scholars in Egypt today are Heba Raouf Ezzat and Omaima Abu Bakr. Ezzat is an Islamic activist and scholar who is a faculty member at Cairo University in the department of political science.

She contributes regularly to newspapers and magazines, is the author of several publications and runs a website, *Hawaa wa Adam* (Eve and Adam), on the Internet. The following quote illustrates Ezzat's views, which address the issue of Muslim women's political participation:

> After witnessing what God gave Solomon, she became a submitter (Muslim), while still the Queen of Sheba... She said, "My Lord, I have wronged my soul. I now submit with Solomon to God, Lord of the universe." Here we witness one of the first Muslim women in charge of a nation, ruling them as a queen of Sheba. Can we learn a lesson from the Qur'an? We should. The lesson is that, God in the Qur'an never put restrictions on a woman in a ruling position. Contrary to what the traditional Muslim scholars and *hadiths*[26] teach, a woman in a leading political position is not against God's system or against the Qur'an. It might be against the chauvinistic views of the men who wrote the corrupted history of *hadiths*.[27]

Ezzat's discourse demands public space for women's views by politicizing the role of mothers as the bearers and keepers of the next generation. She disputes the view that limits women's role in society to child bearing and child rearing on the grounds that the Qur'an does not assign stereotypical roles based on gender. Thus, she insists that the Qur'anic text does not support practices that oppress women in society, nor does it ordain the socially perceived gender roles. Ezzat perceives the family as assuming a vital political role in Islamic society, which therefore ought to elevate it from the private to the public sphere.

Scholars of the Middle East[28] have agreed that one of the most pronounced characteristics of Islamic women's groups is their reaffirmation of nationalist and anti-Western views that resounds with Azza Karam's emphasis on the creation of exclusionary boundaries for building identity and solidarity among these women's groups. These authors explain the debate over gender roles and gender complementarity/equality to be embedded in a larger Islamist discourse that posits Islamism as a reaction to colonialist agendas and frameworks of resistance to Western intellectual domination. Today, according to Haddad and Smith, Islamism is perceived

[26] Prophet Mohamed's sayings
[27] Heba Raouf Ezzat, "Women and the Interpretation of Islamic Resources," *International Forum for Islamic Dialogue*, 1999, www.islam21.org/main/women.htm
[28] Haddad and Smith, as does Duval and Zuhur.

by Islamist women as a liberating force not from male domination and traditional restrictions but from Western oppression and the confining Western categories of gender roles.

> It liberates men and women from bondage to Western constraints on their God-given roles, freeing women to enjoy the roles designed by God for their own happiness and well-being and ultimately for the redemption of the world.[29]

These Islamic scholars are described as women who

> participate actively in promoting the rights and opportunities that they believe Islam truly accords them… [from] a position that speaks from within their own culture, consciously avoiding articulation that represents foreign ideologies or perspectives that seem to reflect Western feminism.[30]

They agree with Islamic women activists that gender complementarity and not gender equality is the true path to women's liberation, and true liberation is that which is provided by Islam for both men and women. They view Western models of liberation as not only irrelevant but harmful and demeaning for women and vehemently reject the term "Islamist Feminist" because of its Western connotation, even though they are actively engaged in pursuing gender equity in society.[31] Omaima Abu Bakr phrases this as follows:

> I don't have to subscribe to any foreign/Western agenda or discourse on feminism and gender. Some of these are simply irrelevant e.g. homosexual rights, the charge that Western feminism is anti-family and an expression of excessive individualism, the problem of secularism, etc. These have become the characteristic criticisms of women generally working on women's or gender issues in Muslim societies. However, one can define one's own context and paradigms for a gender-sensitive perspective.[32]

[29] Haddad and Smith, p. 148.
[30] Ibid.
[31] Ibid.
[32] Omaima Abou-Bakr, "A Muslim Woman's Reflections on Gender," *International Forum for Islamic Dialogue*, 2000, www.islam21.org/main/women.htm.

On meeting Abu Bakr, my initial impression was of a soft-spoken woman who projected a quiet self-assurance. She spoke eloquently and effortlessly in a series of organized thoughts.

Islam is an inspiring religion. I am awed by its scope and magnitude. I am confident in its egalitarian spirit and do not believe that it could have been in any way intended to be harmful to women.

We discussed Islamic women's activism in Cairo. Abu Bakr related to me that she herself attends religious lessons. At that I was really surprised and asked her why she would do that if she herself was a scholar of Islam.

Of course the information that is taught in the lessons is not new to me. I may not be challenged intellectually. But these lessons inspire me. Sherine Fathi, for example, is an excellent speaker. What these lessons do is provide me with "roads to God." Every time I go it renews some aspect of faith that has become obscured in me by daily concerns. I leave with a sense of peace and satisfaction and a renewed religious vigor.

Omaima Abu Bakr described the efforts of Islamic women activists in Egypt as still somewhat new and not having reached the level of maturity that can articulate a philosophy or have a pronounced impact on the norms that have oppressed women. When I asked her if she envisions a day soon when her scholarship and that of Islamic intellectual Heba Raouf Ezzat can reach these activist women, Abu Bakr said that they are trying, but that will take time.

My first meeting with Heba Raouf Ezzat was in her home, but even before I met her we were discussing many issues on the phone. Ezzat's home is a reflection of her personality; creative and authentic. Her living room is set up like a scene from the *Thousand and One Nights*, with a beautiful oriental carpet covering the floor and cushions lining the walls on which her guests were invited to sit. The sound of Qur'anic recital was carried to us through a radio that stood at a distance. As we sat down to begin our conversation we examined one another. We are both in our thirties, both of us are interested in the same issues and both of us are mothers and academics. The similarities between us were offset against the

difference in our approach. Up front I explained my views on religion and my inclinations to view it as a private, personal relationship that gives me space to practice my own notions of what religion can be, but accepts in turn how others choose to view theirs. Ezzat did not comment on this, but later there were to be many opportunities that she took to do so. Although I always looked forward to our stimulating discussions, I was struck by the aftertaste that I was left with, akin to how one would feel after a long and hard chase. Heba Raouf Ezzat's views were always well thought out and researched. Her knowledge of Islamic teachings and Western thought is substantial and extensive. Our roaming discussions were always hard to focus, mainly because her mind was constantly darting in the corners of every idea we exchanged looking and searching for new and novel ways to stretch them beyond their limits.

We discussed issues of freedom and respect. Ezzat believes that personal freedom can be enjoyed so long as it does not impinge on the principles of an Islamic society. One day I found a glaring message from Heba on my cell phone, saying, "Do you still respect?! Gays have come out!" I did not understand it at first until I realized that she was referring to our very first meeting, now months ago, when I had mentioned respect of freedom of religious/social practice. I called her, and she read out to me the day's headline about the arrest of a group of homosexual men partying on a boat in Cairo. Heba asked me,

> Do you still respect this? Soon we will have gay and lesbian marriages in Egypt. And who knows, gay politics and activism. Do you know what this means? It means our society is slipping into oblivion. We are losing the very fabric that makes up the core of who we are. This is where "respect" will take you.

The emphasis on Islamic values and ethics is prominent in Ezzat's conversation. It is not a desire to hold on to a glorious ancient past that motivates her; rather it is borne out of a conviction invested in the value of Islam as a paradigm for social advancement. Ezzat calls herself a liberal Muslim, in the literal sense; she explained to me in so many ways how this is possible for a Muslim woman in Egypt today. For example, she was in England for a year preparing for her masters degree while her husband visited occasionally. While she was there she had to take care of her

children, and in the process discovered that, for example, practicality deemed it necessary to remove the *khimar* (the long veil which reaches to the waist or knees, usually designed in the shape of a pyramid) because she found it too cumbersome to carry her baby and her things when she traveled on public transport. "There is no verse in the Qur'an that stipulates the fashion of the veil as a garment. So even today I do not wear the *khimar*." Rather Ezzat wears a veil that reaches only to her shoulders. As she is a mother of three, she finds that this too has bearing on her status in society and therefore affects the way she deals with male colleagues and friends.

> *I feel that as a mother of three and as a woman now in my thirties there are certain ways that have changed in my social interactions. As a young single woman at university, my religious teaching did not allow me to sit alone with a male colleague. Yet the other day, for example, I met one in the university library and we discussed for some time several issues we were working on. As a Muslim woman, I felt very comfortable doing that as fulfilling my social role as a pious wife and mother entitles me to do that.*

She believes that the political power should not lie within the state, which she views as corrupt and tarnished by Western values, but in the family. To her, Westernization has introduced harmful habits and practices that contribute to the degeneration of Egyptian society, for example the ideas of individualism as opposed to those of solidarity and mutual respect. One of her main arguments, however, is concerned with the negation of the notion of the public and the private spheres, since to her the family is a micro process of the state. Her views on the family are characterized with great emphasis and high regard, but with a liberal slant:

> Family is not an obstacle; it can be turned into an obstacle. Women who stay at home for some time bringing up children are participating in protecting that unit [the family] in society; practicing... socialization, giving their children certain... positive values. Then these women can go and perform other public and equally important roles. No one has 24 hours to devote to only one sphere.[33]

[33] Karam, p. 227.

Working in the realm of NGOs is Omaima Abu Bakr, who belongs to a tradition of Islamic women who have dedicated themselves to improving conditions for Islamic women throughout Middle Eastern history. Born out of a legacy of influential women in early Islam, Islamic scholars like Abu Bakr draw upon key female figures in Islamic history both for inspiration and justification. Their discourse, however, is the product of a global awareness of the diversity in women's experiences. Aside from her job as a professor at Cairo University, Abu Bakr works twice a week at an NGO for women in Cairo dedicated to rewriting Egyptian and Arab history from a women's perspective. The *Women and Memory Forum* conducts extensive research to excavate the histories of women who have played a role in the development of their countries and who have been written out by male-centric views of history. Abu Bakr is well versed in Islamic text with which she engages to produce an understanding that is authentic and also true to women. She believes that the egalitarianism of the text has been obliterated by age-old, male-centric interpretations that have undermined women in Islamic society. Today Abu Bakr, like Ezzat, is concerned with restoring the original intent of Islam to protect women's interests and to dismantle the myths that have impeded their progress.

The impact of Islamic women's activism is questioned by traditional Muslim scripturalists as well as by groups of secular women. The underlying reasoning used by both contesting groups is derived from an essentialization of "women" on one hand and "Islamic" on the other. Neither one of those two groups considers Islamic women as people with agency. They perceive them as passive and subordinated, incapable of empowering themselves or others. This study will widen the lens directed at Islamic women's groups by analyzing the impact of their project on their own as well as on other women's empowerment. Muslim Middle Eastern women have employed Islam as means for activism and as an end in itself with varying degrees and results. In Iran women have actively campaigned for their rights as part of a nationwide project of *ijtihad* derived from the Islamic *shi'ite* doctrine, which encourages its practice among the religiously learned. The practice of *ijtihad* in Islam has encouraged Iranian women to become more involved in learning the *shari'a*, as under Islamic law it has become the only way to argue for women's rights in the Islamic republic of Iran. In the following pages I shall examine the case of Iran to attempt to

seek a relevance between their model and that of Islamic women activists in Egypt. These women's experiences have greatly differed from those in Iran, as Egypt is neither *shi'ite* nor is it an Islamic state. Yet, or some Islamic women in Egypt, the model provided by Iran has played a motivating factor in their quest for an Islamic salvation.

Iranian Islamic Feminism

From a declared anathema to the west, Iran has risen as a new Islamic state defying all predictions of failure and defeat. The case of Iran remains to many Islamists a model of reform, one they view with awe, tantalizing their imagination of what could be. It is no wonder that Iran has received much attention from feminists writing about Islamic women in the Middle East who refer to their Iranian sisters as the ultimate Islamic feminists. Yet, despite their illustrious reputations as activists, women's path to emancipation in Iran is not paved with roses. Afsaneh Najmabadi writes extensively about that road and describes it in the title of one of her articles as "Years of Hardship, Years of Growth."[34] Najmabadi actually adopted the title from one of Iran's most famous feminist journals, *Zanan*, to which both Islamic and secular feminists contribute articles. The author provides an account of the development of the journal's discourse as a lens from which to view the wider scene on women in Iran. *Zanan* covers highly controversial issues such as whether women may be judges, or whether they have the right to reinterpret religious texts and contributions to issues of jurisprudence and family law.

Najmabadi contests views that interpret the women's movement in Iran as being in spite of government oppression. In fact, she explains, women's activism in Iran thrives as a result of Khomeini's decrees of jurisprudence, which are now part of the Iranian constitution whereby the jurisprudent becomes ruler. By virtue of this law, all citizens hold the right to interpret the canonical texts on which the jurisprudence of the rule is based. The result is that many Iranian women have been participating in a vigorous

[34] Afsaneh Najmabadi, "Feminism in an Islamic Republic: Years of Hardship, Years of Growth" in Yvonne Yazbeck Haddad and John L. Esposito, eds., *Islam, Gender and Social Change* (New York: Oxford University Press, 1998) pp. 59-84.

project to interpret the Islamic religious texts. These are not without opposition, and according to Najmabadi they do so with intense conviction.

In the journal *Zanan*, itself one of many such journals in the country, numerous experiments in interpretation have taken place. In fact, *Zanan* writers have gone beyond the traditional forms of interpretation, many of which tend to be ahistorical and to normalize isolated events. Instead, *Zanan* authors have been engaged in an *ijtihad*, which they argue is the right of every Muslim and every non-Muslim who possesses the prerequisite knowledge. They have widened the scope of the Arabic language by enlarging its linguistic construction, going beyond the traditionally understood terminology to examine it within its historical context. For example, one of the central *suras* (verses) of the Qur'an used by some to demonstrate the issue of the divine preference of males to females, the term *qawamun*, is used to describe men in traditional translations to mean "superior to women." In *Zanan*, Iranian women writers explain this term to mean "standing for women," i.e. supporting women. This holds deep implications to gender egalitarianism in the Qur'an, which has often been deliberately overlooked in male-centric interpretations of the Qur'an.

One of the significant contributions of the journal is that it provides public, political and social space for its authors to address religious issues of significant implications to a public audience of women and men in Iran. *Zanan*'s authors are perceived as "public intellectuals" who raise awareness of gender issues. Najmabadi maintains that the most significant consequence of the interpretive activities of *Zanan* is the "radical decentering of the clergy's monopoly over the domain of interpretation."[35] On the feminist front, *Zanan* has succeeded in reconciling the divided fronts of Islamic and secular feminists in Iran. Najmabadi considers this achievement the journal's greatest contribution to Iranian feminism. She explains how secular feminism and Islamic feminism had previously been constructed as mutually exclusive categories projected by the tug of war between the modernizing state and the *shi'ite* clergy.

While Najmabadi exposes the public activism of Iran's feminist intellectuals, Zahra Kamalkhani considers an alternative sort of women's

[35] Ibid, p. 71.

activity that takes place in the religious sphere, in particular religious meetings.[36] Kamalkhani studies the organizational and educational aspects of these meetings while reflecting on their benefits for Islamic women. She attended regular religious lessons in private homes and public religious buildings, and comments on the novelty of these practices to women who now find in these occasions "religious reward and integration as active believers in a society affected by intense competition caused by a constrained market for economic and employment opportunities."[37] Kamalkhani emphasizes the political dimension of women's religious meetings by highlighting the relationship between the religious knowledge generated to women, which she perceives as the "popular" type, during the meetings and the government's goals of imparting its own religious curriculum, defined by Kamalkhani as the "post revolutionary reformulation of Islamic mass education."[38] This has resulted in the transformation of women's popular traditional religious meetings into loci of political mobilization, which has contributed to the enhancement of women's public participation in Iran. Kamalkhani finds this illustrative of the way religious knowledge is imparted to women through popular means in contemporary Iran.

Whereas Najmabadi looks at the journalistic efforts of *Zanan* and Kamalkhani examines popular religion, Haleh Afshar analyzes the impact of Islamist women's strategic negotiation in Iran.[39] She focuses on one issue that has witnessed a total reversal since the advent of Khomeini's *shi'ite* government, the area of women's participation in the judiciary. Afshar recounts the escalating events that illustrate the dynamics of interplay between an essentially patriarchal system and women in legal occupations. Women members of the *majlis* (parliament) sought to oppose the Committee on the Judiciary over their proposal to exclude women from assuming office in the Iranian judiciary system. The *'ulama* were fearful

[36] Zahra Kamalkhani, " Reconstruction of Islamic Knowledge and Knowing," in Karin Ask and Marit Tjomsland, eds., *Women and Islamization: Contemporary Dimensions of Discourse on Gender Relations* (Oxford: Berg, 1998) pp. 175-193.
[37] Ibid, p. 190.
[38] Ibid, p. 188.
[39] Haleh Afshar, "Islam and Feminism: An Analysis of Political Strategies" in Mai Yamani, ed., *Feminism and Islam: Legal and Literary Perspectives* (London: Ithaca Press, 1996) pp. 197-215.

that any female representation in the judicial system would eventually lead to a subversive infiltration of women into an area from which, they repeatedly asserted, Islam had banned women. Their perspective was reinforced with arguments about the unsuitability of women's nature to be judges. The issue of male unemployment was also used as a rationale by some to justify their refusal.

By capitalizing on their knowledge of the Islamic legislative texts and the pressing need of the new Islamic republic for Islamically versed lawyers, Iranian women's ability to negotiate with the patriarchal authorities determined the outcome of the situation in their favor. Despite these successes, however, the plight of Iranian women, who had lost all their gains for rights before the advent of the revolution, still remains a dismal one. As Kamalkhani has shown, Iranian women discover toeholds of support in religious meetings, which involve them in an Islamic activism. Afshar and Najmabadi point out that these women are not merely reinterpreting the Islamic texts but are also struggling with patriarchal systems run rampant. Whether or not Islam can be used to fight patriarchy as well as it has served it remains the outcome of an experiment still in progress in Iran.

A number of studies reflect varying degrees of skepticism over the projected outcomes of an Islamic feminism for women. Haiedeh Moghissi explains this issue as resulting from misplaced postmodern analysis.[40] Moghissi contends that Islamic resurgence has been painted in apologia by contemporary Western discourse, which uncritically employs post modernist analysis in an attempt to provide an anti-Orientalist discourse on women in the Middle East. In her view, the body of work on Islamic feminists today is not realistically representative of these women's voices in that it overplays the picture of women's agency and empowerment while paying little attention to the negative side of the coin, mainly what she describes as fundamentalist misogyny. Moghissi's issue is with an attitude that coerces Muslim women into believing that an Islamic framework is their only indigenous option. This, to her, implies that feminism will be a privilege restricted solely to Western women.[41] Homa Hoodfar expresses a similar concern with overzealous representations of an Islamic paradigm for

[40] Moghissi.
[41] Ibid, p.9.

women's empowerment.[42] She argues that Islam and *shari'a* have been employed by governments to deny women their rights, and fears that this misuse of Islam may be an acceptable rationale to international organizations concerned with women's development such as the United Nations, who may be led to tolerate misogynist practices as acceptable of non-Western religions. Others see a necessity to combine Islamic frameworks with other alternatives in order to interpret the problems that impede women's interests in the Middle East.

> This would not necessarily undermine the importance of Islam, but it would allow us to analyze the role of Arab Muslim women with the use of analytical frameworks that, for example, draw on the sociology of religion and on the political and economic dynamics of nationalism and dependency. By showing some of the contradictions that arise from remaining solely within the Islamic discourse, perhaps we can begin to answer some of the questions relating to Arab women.[43]

The need to consider Islamic frameworks in parity with secular paradigms is more than a practical necessity, according to many scholars. Deniz Kandiyoti explains that because some governments in the Middle East have depleted their capital of popularity based on cultural nationalism, they have resorted to an Islamist discourse to gain acceptance and to legitimate their rule. However, many of these states leave little room for nonsectarian, pluralistic representation. As a direct consequence, according to Kandiyoti, men and feminist women find themselves with little choice than to argue for their demands from a religious framework. She reiterates what she has often pointed out, that Islam or any religious text is subject to a multitude of interpretations and hence can accommodate political ideological justifications or regime legitimation accordingly. Islamic feminists are already employing an Islamic paradigm to legitimate their demands, but the outcome of this kind of activism, according to Kandiyoti, is contingent on other factors, and in their case patriarchy poses as a central axis.

[42] Homa Hoodfar,"Iranian Women at the Intersection of Citizenship and the Family Code: The Perils of 'Islamic Criteria'" in Suad Joseph, ed., *Gender and Citizenship in the Middle East*, pp. 287-313.
[43] Maha Azzam in a seminar on Arab women, in Hijab, p. 49.

It remains depressingly true, however, that it has taken Islamist feminists nearly twenty years to claw back bit by bit the ground lost by the abolishment of the Family Protection Law of 1975, which took one speech by Khomeini to demolish. This task remains not only incomplete but is vulnerable to the vagaries of internal power struggles. To conclude, my relative pessimism concerning the possibility of pluralistic outcomes for women under Islamic regimes derives neither from the assumption of some implacable fundamentalist logic or from the nature of religion per se. It is based, rather, on the recognition that in an increasingly interconnected world where accommodation and compromise in almost every area of social life are essential for survival, the area of gender relations and of women's conduct singles itself out as prime terrain for conflicting bids for social control.[44]

The case presented by Iran demonstrates that in an Islamic state the discourse of resistance that women employ is primarily based on Islam. Other discourses exist, such as secular feminism, which works in unison with women's Islamism. However, it is the political and social circumstances prevailing in Iran that render one more effective than the other. It is indeed true, as I have shown in the above account, that gains were made for women in Iran through an Islamic feminist approach. However, as Kandiyoti points out in the above quote, progress gained by women remains contingent upon the norms that dominate the public sphere at any given time and place. Women, as are men, are caught up in various political processes as we have seen in Egypt, which influences the nature of their discourse and the direction followed by their activism. Iran posits an example that is useful for a consideration of women's options under an Islamic regime. While such an environment may be ideal for women arguing for their rights from an Islamic perspective, it also demonstrates that Islam cannot be overburdened, as a single paradigm, with the task of liberating women. The platform on which women's rights are contested, even in Islamic states that purportedly follow the "true Islam," is nevertheless occupied by conflicting interests such as patriarchy, failing economies and political conflicts.

In Egypt many Muslim women today are involved in a quest for religious piety, which provides them with a vision for perfecting themselves as well as the society in which they live. Their vision is not predicated on

[44] Deniz Kandiyoti, "Islam and Feminism: A Misplaced Polarity," *Women Against Fundemamentalisms*, #8, 1996, p. 13.

resistance, and in fact Islamic women activists in Egypt, unlike those in Iran, have yet to enter the sphere of political contestation of women's rights. On the contrary, Islamic activism to these women is concerned with providing harmony and self-contentment through perfecting such qualities as *sabr* (perseverance), piety, and discipline. By being "good Muslim women," Islamic women activists create a strong basis for self-improvement and for the improvement of Egyptian society.

Muslim women's activism in Egypt provides an array of activities that take place in different social spheres. While this activism clearly occupies a public space in society, it is yet to be described as a united voice. However, more women every day are drawn into the midst of Islamic organizations because the nature of these organizations and their social context contribute to the creation of its incredible force of attraction. In this chapter I have attempted to create the historical backdrop to the emergence of women who adopt Islamism as means to improving themselves and seeking closeness to God, as well as those who envision in Islam a road to emancipation based on their view of Islam as an egalitarian religion. In the next chapter I will present the women I have worked with in Cairo, the Islamic activists who through diverse activities work to improve society based on Islamic ideals that they endeavor to attain. I shall argue that Islamic women's empowerment is linked to wider patriarchal ideologies of Islamism, which at their historical specificity create indigenous empowerment for Islamic women.

CHAPTER THREE

EMPOWERING THE SELF: TRADITION, PATRIARCHY AND ISLAMISM

Islamic women activists ride on the crest of a revivalist wave of Islamization in Egypt. Within the last decade they have evolved as a diverse group in society, yet can be predominantly characterized by an Islamic zeal aimed at attaining higher levels of religiosity and self-enhancement. Their commitment to addressing wider social causes and concerns is noted throughout the country, providing tangible results that attest to their skills and organizational abilities. The widespread activism of Islamic women in Egypt today has caused much controversy among scholars who seek to interpret the nature of this activism predicated upon Islam with the heavy burden this religion has come to carry, of being regarded as restrictive and unjust to women. My purpose in this chapter is to illustrate the notion of empowerment as articulated, through the activities, relationships, and discourse of the two groups of Islamic women activists I have studied.

The following account of my ethnographic data will be organized around four important themes. The first theme centers on the ways Islamic activist women create a social world organized around a shared understanding of Islam that defines their relationships with one another and with others. The second theme illustrates the nature of the camaraderie and support the women exchange with one another. The focus on self-enhancement according to Islamic teaching constitutes the third theme. The implications of the spiritual and physical attainment of women is highlighted in the fourth and last theme as Islamic women activists demonstrate the impact of their religious practice in situations where they resolve conflict, ways they describe themselves, and finally in how they define relations of power and empowerment.

In investigating the subject of empowerment for women in the Middle East, research needs to take account of two theoretical postulations. The first, as argued by Talal Asad, assumes that the Middle East and Islam in particular should not be understood by means of hegemonic Western

notions of modernity and liberal thought which view tradition as a phase or as set against an evolutionary scale of modernity. Rather, "tradition" should be interpreted as an ideology on its own, both authentic and creative. Hence, Asad proposes a treatment of Islamic movements, not simply as "reactionary," meaning they oppose Western modernity, but on their own terms as growing, changing and modifying their discourse in relation to their beliefs and to other traditions.[1]

Second, empowerment as understood by liberal views of the individual in Western thought, in particular feminism and development theory, is inadequate in understanding the complex formulations of empowerment in Middle Eastern societies. A number of Middle Eastern scholars[2] have argued that Western liberal ideology on which concepts of the construction of agency is predicated should not restrict our understanding of agency in the region. I will attempt, therefore, to interpret the empowerment of women who choose Islam as a paradigm for self-enhancement through a consideration of the notion of the self as articulated by Middle Eastern scholars. I will also draw upon Foucualt's subjection/power paradigm, which explains his notion of self-formation and agency.

I argue in this work that Islamic women activists force a re-examination of the issue of empowerment and agency, as these women who are clearly involved in processes of self-development and reinvention do not comply with feminist liberal paradigms that have traditionally been employed in interpreting women's agency in the Middle East. Islamic activist women are engaged in activities and practices that serve to attain goals to self-improvement that are not in line with those of Western feminism. Whereas freedom, autonomy and liberation from male domination are goals that Western feminism regards as necessary for women's empowerment, Islamic women's activism demonstrates the irrelevance of these ideals to the women who participate in it. Instead, these women seek ideals that are defined in Islamic ideologies—articulated in some cases by men—such as piety, perseverance and self-discipline as means of perfecting the self. While

[1] Mahmood, "Interview with Talal Asad...."
[2]. Asad in ibid, and Suad Joseph explore these notions of the self in Middle Eastern societies. I am indebted to Dr. Joseph for sharing with me her insights about the notion of the self as she has come to see it through her extensive research about the subject.

empowerment, resistance and even political action may be engendered as a result of Islamic women's pursuit of higher religious attainment, these are not regarded as their ultimate goals but rather as means to further their religiosity.

Research Setting

Al-Fath. The first of the two Islamic PVOs I visited is the one I call al-Fath. Al-Fath is small and very minimally funded. Donations constitute one quarter of their revenue, which takes the form of money, clothing or any items in good shape but not needed by the donors. The women of al-Fath generated their limited funds by organizing clothes drives and selling them for the public at very low prices. For example, a pair of pants cost from LE5 to 10 (Egyptian Pounds), a dress was for LE5 and a pair of shoes was from LE7 to 20.[3] A single sale earned approximately LE5,000, which was barely enough to cover the monthly support sum of LE50 that they gave to each of the 287 widowed women. They spent some of the money they collected on foodstuff, which they cooked and sold every other week at a small sale.

The women of al-Fath worked in two rooms attached to a large mosque, the Mosque of Abu Bakr, which is run by a group of men appointed by the Ministry of Religious Endowments. The women and the men worked for different organizations. The women worked for al-Fath PVO, which is under the auspices of the Ministry of Social Affairs (MOSA), while the men were under the umbrella of *al-awqaf* (endowments), which supervises Islamic establishments in Egypt, including mosques. Because of the very close proximity to one another, it was an awkward arrangement for the women and one that later led to conflict despite the separate affiliations of the two groups.

Al-Fath occupied the rooms in the back of the mosque, with an unassuming entrance—only a small sign hung crookedly from the top of one door—that did not draw much attention from passers-by. Inside furniture was minimal, with priority of space given to clothing donations that lay stuffed in boxes crammed together on shelves built into every possible space. The walls and floors were spotless. A wobbling fan dangled

[3] At the time this research was conducted, One US Dollar equaled LE4.25.

from the ceiling, creating the only source of air other than the open door in the two stifling hot, airless rooms. The mosque of Abu Bakr, which was run by the men, was by contrast large and airy and overlooked the main street. It was built on approximately half a *feddan*[4] with a large banquet hall attached to it. The exterior of the mosque was beautifully decorated with Islamic designs and the interior was carpeted with the wall and pillars covered in costly marble. Three rooms, accessed from the inside of the mosque, were occupied by the administration. The man in charge of the mosque was *Hag*[5] Abdel-Samad, who was in his fifties and worked as *khadem al-gami'* (lit. one who serves the mosque, the keeper of the mosque).

Like most other Islamic PVOs, al-Fath was officially registered with MOSA, as the women there proudly told me. They took pride in relaying the fact that al-Fath was an official establishment recognized by the Ministry. The Islamic women activists at al-Fath came from the wide range of the middle class in Egyptian society, their ages ranging between 50 and 70. While most of the women were from the middle class, three of them, *Haga* Amira, *Haga* Naguiba and *Haga* Sanaa, were upper middle class. Only two of them held a university degree, and one worked as a dentist. The rest of the women were mostly widowed housewives who had married in their teens and did not finish their high school education. In Egypt, educational credentials are valued in society, especially beyond high school and among the middle class. People are often described by their *shehadas* (certificates) received from educational institutions.

The women placed a measure of importance on the official capacity of what they were doing. To them, working at al-Fath gave them a sense of importance and value. Although the ministry was not much involved with their religious activities, the women kept very detailed records of revenues and donations and their logs were always ready for any official who might decide to examine them. The pride the seven women took in the center also came from the magnitude of the services they provided to the widowed women and their children who relied on al-Fath, compared with how very few resources they had.

[4] A *feddan* is slightly smaller than an acre.
[5] *Hag* means one who performed the pilgrimage. Used for males. It is a term used for older people in Egyptian society that implies respect. Female word is *Haga*.

The widowed women who benefited from the services of al-Fath came from a nearby neighborhood of lower socioeconomic level. They were in dire need of financial and social support in raising their families and whatever they received from the center went a long way with them, as one *Haga* told me. In order to register with the center, *Haga* Nasal or *Haga* Sanaa paid a visit to the woman's home to assess the level of the need. If they approved, the woman was invited to register with the center in order to receive the services it offered. These included the monthly allowance, provisions for schoolchildren such as uniforms and supplies, supplies for Ramadan, the Muslim month of fasting, and gifts of money and food at festival times. In instances when girls were getting married, the women who worked at al-Fath collected money from their own families and friends and bought the bride's *gihaz* (trousseau),[6] which included clothing and furnishings for the new home. In many ways, Islamic women at al-Fath gave of their time and effort as they managed to serve as a dependable source of support for families who had nowhere else to go.

Of the seven women who worked at al-Fath, *Haga* Amira (who was also the one who showed me round and facilitated things for me) stood out as the most vocal. I was introduced to her through a common friend, and when I arrived at the center early one morning it was she who greeted and presented me to the other women who started trickling in after 10:00am. *Haga* Amira herself was 70 years old and a widow, and was dressed in well-tailored clothes. Her hair was covered by a white scarf expertly folded into place with the help of pearled bobby pins. All the other women at al-Fath wore the same white head veil. She had two married children and was a grandmother to four teenagers. Her husband had left her some money to live comfortably, and although she said she had several health problems she mentioned that she never neglected her work at al-Fath. She could not live, she said, without having this wonderful opportunity to be useful. She was sure her health would deteriorate if she were to give it up.

As we sat at a table placed in the center of the larger room engaging in conversation, the other women joined the discussion, *Haga* Sanaa, *Haga* Mona, *Haga* Safia, *Haga* Naguiba. *Haga* Nimat and *Haga* Nawal agreed completely with what *Haga* Amira said. We discussed the weather, how

[6] In Egypt the bride brings her furniture to the matrimonial home.

many children I had, what my husband did and finally what I myself was doing. I explained that I was a schoolteacher and that I was conducting my studies in social anthropology and hoping to earn a master's degree in the subject. At this, I was asked what "social anthropology" was. Their animated interest in my studies soon came to a halt when *Haga* Sanaa, one of the oldest there, called everyone to order in a soft voice as it was time to start their weekly meeting. Alhough she was the one who announced the beginning of the meeting, she did not run it. In fact, as the meeting progressed, it seemed as if the group ran its own meeting collectively.

Haga Amira and *Haga* Mona were in charge of the orphans. *Haga* Sanaa and *Haga* Nawal were in charge of the widowed women. *Haga* Nimat and *Haga* Safia worked on projects such as arts and crafts for the women and helped supply the charity bazaars with products the widowed women produced. *Haga* Naguiba, who at 50 was the youngest of the women, acted as liaison with the provinces and visited a small village about 45 minutes by car from Cairo every other week to distribute supplies and donations to the poor. *Haga* Naguiba also acted as treasurer and managed the expenditures and revenues, but she did not make decisions about who took precedence for funding.

The meetings, which were held at al-Fath every Tuesday morning, were an informal affair. No papers were shuffled, no agenda was followed. It was a time to come together to discuss what each one was doing and to mention what problems, if any, they needed help with in order to do things better at al-Fath. Each of the women gave a short review of her activities and said whether she needed anything. *Haga* Amira said she needed more cupboards for storage, *Haga* Safia needed yarn, and so on. They prioritized the needed items as a group, but nothing was written down. They relied entirely on their memories and on reminding each other. There were no computers, no calculators and no filing cabinet, yet the women were accomplished in their activities and organized all their events superbly well. Those events I attended such as charity bazaars and parties for orphans began on time, proceeded as planned and accomplished their goals.

Al-Fath appeared to me a nucleus of activity in which the women worked amiably with one another although, as I observed, with differences of opinion and personality that they learned to overcome. These women worked in an egalitarian atmosphere, and as each one was responsible for a

clearly defined task they did not interfere with one another, nor did they impose their will on one another. Once when *Haga* Amira was discussing the issue of school uniforms with *Haga* Naguiba, she looked tense and used her hands and body more than she usually did in expressing herself. Later, she confided to me that *Haga* Naguiba had refused to give her money for the white school shirts she had managed to get at a very low price of LE10 each. *Haga* Naguiba said she did not have the money. *Haga* Amira simply told me that rather than argue with *Haga* Naguiba, she would just pay for the shirts from her own pocket as the deal was too good to pass up. When I looked surprised, she said that she would not argue with *Haga* Naguiba because she respected her decision, but since it was all for the sake of God she would just put up the money herself.

When a situation merited arbitration, the women resorted to calling the "*Haga al-kabira*" (the senior *Haga*). The *Haga al-kabira* worked from the main organization and seldom visited the center except to give religious lessons. When she did she performed symbolic gestures, such as giving out awards at a ceremony for orphaned children that the center had organized. She appeared to be in her mid-70s and, judging by her all-black, loose fitting clothes, she appeared to belong to the lower middle class. The *Haga al-kabira* had a dignified demeanor that was mirrored in the way she held her head and her body. All the other women at the center showed her great respect, but I did not get the impression that she was treated as their leader. One of the women, *Haga* Safia, whispered to me when I asked her if she could introduce me, "She is not really our boss. We only invite her to these events so she can support our center when we need her help."

Al-Hilal. The second site in which I chose to work was on the other side of the suburb and operated from a large building also attached to a mosque. Al-Hilal, as I will call it, was an incredibly busy place where twenty women devoted their time most days of the week. It was an impressive building rising three stories high. The ground floor was used as a day care center for children of poor working women who paid only a nominal fee. The second floor boasted a large carpeted hall where lessons took place and charity bazaars were held. People came and went all the time, mainly women and children. They either attended religious classes on the third floor, or received donations, or learned the various vocational skills

that the women activists taught. These included cookery, weaving and literacy classes. The large mosque attached to al-Hilal was run by the women. Although the mosque was an impressive edifice on the ground level, it was not open regularly and, as is the case with private mosques, was only used for special occasions such as the Friday prayer for women.[7] It was smaller than the mosque of Abu Bakr, which was run by the government but was just as well maintained. The al-Hilal center was built in the 1990s with individual help from the people in the neighborhood. The center belonged to a network of Islamic women's PVOs run by women *for* women, which has branches all over Cairo. These branches receive annual revenues of donations amounting to hundreds of thousands of Egyptian pounds. Moreover, al-Hilal was supported by a network of professionals who offered their services to the center as charity free of charge, which the center in turn graneds to the needy. These services included healthcare, education and government and administrative help in overcoming the hurdles of Egyptian bureaucratic red tape and facilitating many of al-Hilal's projects.

The Islamic women activists of al-Hilal all came from different backgrounds and age groups, but they were mostly in their late 20s to late 40s, as opposed to the Islamic women at al-Fath whose ages mostly lay in the 60s range. The socioeconomic and educational backgrounds of the Islamic women activists differed between al-Fath and al-Hilal. Whereas the majority of the women had not completed their high school education at the former, at al-Hilal almost all the women had graduated from Cairo University and a number from the American University in Cairo. Al-Hilal's Islamic activists belonged to the upper and upper middle class, although two of them came from the lower and lower middle class. As with al-Fath, at al-Hilal all the women worked on an equal footing, with each one responsible for a certain job.

Working at al-Hilal were a number of women with whom I went to university. Salma and Laila both attended AUC in the mid 1980s as I did. There were others who studied there at a later time, such as Dina. At the center I met Maha, a graduate of economics and political science from Cairo University. There were several other women at al-Hilal to whom I was

[7] For a comparison between private-run and government mosques see Patrick Gaffney, *The Prophet's Pulpit: Islamic Preaching in Contemporary Egypt* (California: University of California Press, 1994) p. 48.

introduced but with whom I could not closely interact as they mostly worked outside the center and only came in occasionally. Nadia was one of those. Her job was concerned with distribution, and because she had a car and a driver she was able to visit homes, hospitals and orphanages every week to check up on them and report back their needs to *Doctora* Zeinab and the others.

The type of leadership at al-Hilal differed from al-Fath. The administration was centralized in the hands of one figure, Dr. Zeinab or, as she was called in Arabic, *Doctora* Zeinab. (The rest of the women at al-Hilal were called by their first names without the title of *Haga*, which was commonly used at al-Fath. I think this was because in Egypt only older women are called *Haga*, and the women at al-Hilal were in a younger range than those at al-Fath). Dr. Zeinab, who was in her late forties, was a retired physician who commanded great respect and admiration from the women who saw in her a role model. From what the women in the center and others from outside recounted to me, *Doctora* Zeinab was regarded as a very dedicated and hardworking Islamic woman whose views were described as moderate and not extremist (a "moderate" Islamic woman was often more admired and liked among the majority of the women in al-Hilal). One woman, Dina, described her as follows:

> She is amazing. You know, she is a medical doctor. Her husband is also a very famous surgeon. Yet despite her social level, I saw Doctora *Zeinab cleaning the toilets by herself right before one of our charity bazaars. When one of the other women suggested that she would call one of the cleaners,* Doctora *Zeinab said, "Please don't keep me from earning good deeds from God." You see how modest she is?*

Doctora Zeinab sat in front of me dressed in a veil that covered her hair to below the neck, with her arms covered by a silk blazer. A matching skirt went down to her ankles. *Doctora* Zeinab carried herself with confidence and had a piercing gaze. She saw her main goal as "bringing out the good in people." Laila, who worked at al-Hilal, told me:

> *I have been attending* Doctora *Zeinab's religious sessions since 1991. I find her an open-minded person, worthy of respect. Her knowledge about Islamic theology and teaching are*

> outstanding, but when there is something she is not sure about she admits it and doesn't skirt the subject. She spends most of her time discussing behavior, which she finds more important than reading the Qur an for the fifteenth time.

I noted that despite the fact that *Doctora* Zeinab was the main decision-maker at the center, she projected a sense of camaraderie and warmth that was impossible to miss. However, when I was first introduced to her by Laila, who was an acquaintance of mine from university, *Doctora* Zeinab was very reluctant to talk with me. Even when I explained to her that I was studying the phenomenon of Islamic women activists for a Master degree, she flatly told me that she did not want any undue attention. However, she agreed to grant me her time on two occasions solely because I was recommended by Laila, whose opinion she valued highly, and after our first conversation she allowed me to visit the center. We sat in the corner of the big room on the second floor. From the corner of my eye I caught fleeting glimpses of women as they literally darted from the door straight to the rooms in the back of the hall and out again carrying out their chores. A group of girls aged between eight and twelve was gathered round Laila in the further end of the room, patiently sitting for a lesson on *salah* (prayer). I learned from the women that the rooms on the inside made up a kitchen, in which the women cooked a variety of food dishes that were sold in the nearby grocery stores (called supermarkets in Cairo) to generate funds. Five or so of the women who were being trained to cook wore aprons, gloves and shower caps on their heads as they took the cookery lessons and later came out to one of the tables in the hall to pack the cooked food.

When our conversation was over, *Doctora* Zeinab went across the hall to where the girls were taking their lesson. She joined them and began the midday prayer. Everyone stopped what they were doing and proceeded to put on wider skirts, which were identical in design, over what they were wearing. The reason appeared to be that the women did not find their regular clothes appropriate for praying, even though they completely covered their bodies in accordance with Islamic teaching. This signaled to me the women's concern with making their prayer as perfect as possible. Prayer was of such importance to these women that they had to wear these specially designed garments over their skirts to ensure that all prayer requirements were fulfilled. As the prayers began I noticed how in Muslim

prayer people have to stand shoulder to shoulder. In front of me stood the women of al-Hilal praying to God, each shoulder pressed against her neighbor's, thus demonstrating in action what their activism has come to create between them, a kind of solidarity that runs very deep.

Forging Bonds to Better Selves

The Islamic women I had observed and interviewed did not constitute a homogenous sample; in fact, their most common characteristic was their age—in other respects they were very diverse. Most studies of Islamic women in Egypt have remarked on the same issue. John Esposito has observed that Islamism has shaped women's social status by describing Islamic women today as "a new emerging alternative elite, modern, educated, but [more] formally Islamically oriented than their mothers and grandmothers."[8] Scholars reason that Islamism addresses itself to women of various walks of life and creates a unifying factor among them, one that transcends class and economic standing. What was clear to me, however, was that not only was there diversity between the groups, but also within them. Yet, though individual views may vary on gender issues and women's rights or reflect degrees of religious commitment, my observation was that in the two centers the uniting factor between them was their vision of Islam's role in society and their goals to work towards higher religious attainment.

From what was revealed in conversation and the interaction between them, it was clear Islamic women activists in both centers were communicating and working together with no class or socioeconomic barriers. Their sense of solidarity went beyond the superficial and embraced diversities that in the absence of their religious activism would otherwise have played a part in their social world. This was confirmed in my discussions with a number of them. Laila, who came from an upper-class background and who had been working at al-Hilal since it started in 1991, mentioned to me:

> *You know, there is so much love here at the center. I feel so pleased when I come, because of the prevalent atmosphere of*

[8] John Esposito, "Introduction" in Haddad and Esposito, p x.

> *warmth and giving. Some of the women who help come from very simple backgrounds, but there are no differences between us. We are all one and the same and we all come here for the same reason, to become better people. That is all we want. The center is not like the Rotary Club[9] where everyone goes to show off their material wealth and how much charity work they have done. Here we work quietly. It doesn't matter who did what or whether someone did more important things than others. To us what matters is that things are done to make even a small difference in people's lives.*

To me what was most interesting in Laila's account was the distinction she made between a secular organization and an Islamic one, using the notion of materialism as a distinguishing factor. Laila set al-Hilal (and consequently herself and the others who worked with her) apart from other associations that were not Islamic, and in the case of the Rotary also Western, by noting the religious morals of the participants. By constructing "the other" as materialistic she was also forging an identity of the opposite for herself and those who worked at al-Hilal. The drawing board in this comparison was indeed, "Who is the better Muslim?" It was therefore not an issue about class or socioeconomic levels as much as about what one did with these privileges or lack of them. Thus the cross-class phenomenon of Islamic activism was enabled because the value system of such organizations employed a framework altogether different from class and economic level. This frame was based on the notion of the ideal Muslim. People were measured against that frame of reference that in its ideology ignored materialism and focused on the spiritual. The following quote was from a religious lesson I attended at the mosque of al-Nasr during which the *da'iyah*, Sherine Fathi, said to an audience of 300 middle-class women:

> *God gives material things to everyone; those he loves and those he doesn't, but faith is reserved only to those he loves. Your next door neighbor gets a new Mercedes. So what? Anyone can have a Mercedes. But the faith that you have is yours alone. God has chosen to give it to you alone!*

[9] The Rotary Club is an internationally affiliated secular, philanthropic association.

The issue of Islamic activism as a cross-class phenomenon that spreads across class barriers is a new development of what the literature of the 1980s[10] has observed about Islamism, which saw it only in terms of a lower-middle-class phenomenon. Many have noted that the lower middle and lower classes in Egypt have been known to be more conservative and adherent to Islam than the upper class, especially during times of economic difficulty. However, what is gleaned from remarks such as Laila's and from general observations of Islamism today is that the women's Islamic movement has cut clear across class barriers, and more importantly provides a sense of solidarity and belonging that no other movement has afforded women in Egypt before. This resonates with my informant's views which comment on the sense of belonging and team spirit that is prevalent among their groups despite personal and class differences. The lack of emphasis on class, as marked by demonstrations of wealth through conspicuous consumption, contributes to the popularity of Islamic activism among women today. This fact, which is also supported by my findings, explains the accelerated increasing numbers of women who join Islamic organizations.

Another woman who made a distinction between Islamist charity work and the secular Western model represented by the Rotary Club was *Haga* Amira at al-Fath, who mentioned to me that she was not very fond of the Rotary's nature of work. She found it difficult to keep up with the women there showing off their wealth and the constant competition between them, although she herself came from a well-to-do family. *Haga* Amira mentioned that her sister-in law was a member of the Rotary Club and attended regularly. At al-Fath, *Haga* Amira said, there was no need for all the pretension. Several of the participants could not afford many things like dressing well or contributing from their own money. Explaining the reason women placed less emphasis on class and economic differences, she sighed and quoted the same rationale she had used before: "It is all for the sake of God."

The enhanced sense of camaraderie among the women as a result of their activities is also noted by researcher Soroya Duval, who observed

[10] Guenena.

various groups of Islamist women in Egypt.[11] She remarks that psychological as well as social dimensions promoted the sense of solidarity and support between the women. She states that these traits have enhanced women's resolve and inner calm. From her observations Duval notes, as I did, that the strong emphasis on sisterhood, community, and shared values contributed to the women's sense of well being at al-Hilal. The sense of solidarity, satisfaction and bonding that comes from helping others was emphasized by many of the women as not just what made them feel good about regular attendance, but also as the main reason that kept them coming back and sticking to the group. One *da'iyah*, Salma, told me as we sat on the floor in the carpeted hall of al-Hilal after the afternoon prayer:

> *There is a strong sense of obligation that ties us together. Though we are here because we want to help others, we are also bound together by feelings of obligation. Many of the tasks we perform are because as many women gave me their time, effort and patience in trying to explain to me Islamic theology, like* Doctora Zeinab. *If she says to me, "Ya Salma, we are stuck, so and so is sick so could you please take her and go down to Shubra (an area of lower socioeconomic level in Cairo)," how can I say no to her? It is not just embarrassment that makes me say yes every time, but it is also because I want to give back what I have taken. After a while giving becomes a habit. This is why I am now part of the group.*

Salma was 36 years old and a mother of two. She graduated from AUC with flying colors, even joining the faculty of her department by teaching part time. At the time however, Salma had no time for AUC. She was too busy working at al-Hilal. I asked Salma what she thought made her students at al-Hilal keep coming back. She said that women came to her house where she gave religious lessons for many different reasons. Some may be just enjoying a respite from the housekeeping chores at home. Others could be trying to find solutions for their problems. But the majority, she said, come back because they wanted to learn about the true Islam. Salma concluded that her job was to make sure that they were interested and that they left with a good experience so they *wanted* to come back. She said that by

[11] Soroya Duval, "New Veils and New Voices: Islamist Women's Groups in Egypt" in Ask and Tjomsland, pp. 45-73.

making herself accessible, welcoming, and friendly she created a favorable atmosphere for women to become involved:

> *I am not their teacher and they are not my students. We are all the same here. I don't hold a grade at the end of the month over their heads. They learn the verses I assign them not out of fear of failing the grade but because they love and respect me.*

Thus Salma sought to create in her attitude with her audience a sense of caring and love that went beyond the religious to human bonding that ties people together and encourages them to approach their religious lessons with eagerness. What Salma described rang true with the attitudes of all the other *da'iyat* that I observed in lessons. They were congenial, friendly and made a point to remember my name and the names of my children. By asking after my children they managed to make me feel as if I were welcome and that they cared. What I also noticed in Salma's talk with me was that she was describing a teaching technique as if it is were some method the *da'iyat* had to learn. Salma went on to say that not only did the *da'iyah* have to be modest, open, and friendly, but that she had to be able to "read" her audience to know exactly "where it hurts." I was visibly surprised at that. "Where it hurts?" I asked.

> *Yes, our job is to spread Islam and knowing what affects your audience is the first thing that separates a good preacher from one who is not. Take, for example, Sherine Fathi. She is renowned for her ability to address a wide variety of people. Our leader, Umm Aziz, always sends Samira to special places that need a strong preacher. Umm Aziz would say, "Samira, you should go there for a while," and Samira would go. Umm Aziz is always able to tell which mosques need which* da'iyah. *That is how it is done.*

A Women's Empire

Not all Islamic women activists can aspire to be *da'iyat*, nor do they all want to. Each one of the women helps in whatever way she finds possible. Salma continued with her discussion with me by describing the array of tasks that they undertook at the center:

> *We provide health care and access to services through the various support systems that we have. Our activism financially supports families and provides all the needed trousseau items for young brides. We find job opportunities for others. Our activities include helping young girls and boys with schoolwork by organizing after school tutoring for poverty-stricken neighborhood schools. We also teach literacy lessons to illiterate girls and women, in addition to the religious lessons and sermons that we organize. Each sermon is well researched in advance, not necessarily by the person who delivers it. We have a whole team of women who are not fond of preaching and who are better at writing. The sermons you have attended at the mosque by Sherine Fathi were not written by her. None of them were. She is now very famous, but mainly because of the team work that supports her. The lessons we teach to children follow a written curricula which are distributed to each* da'iyah. *Every season, the curriculum is updated and modified.*

I learnt much from the women I worked with about their ways of performing their activism, how they organized themselves and the well-planned teamwork in which they were engaged. What was remarkable about these accounts was their emphasis on pooling the resources of the women who participated in Islamic activism. No one was useless, everyone was valued and contributed of her own accord to further the teaching of Islam as a means to closer proximity to God. It soon became apparent from their accounts, however, that these women not only relied on teamwork but that they mobilized extensive resources in society for their causes. For example, the women had a health network to which those who were responsible for health care channeled their cases. Doctors and medical facilities, for example, provided services for the women's organizations free of charge on a purely voluntary basis. Similarly, networks were established with clothing factories and even grocery shops with which the women activists were constantly in touch, supplying them with goods at half price or on special occasions, without charge.

Manal was a young woman who helped in teaching literacy classes at the center and also taught some of the groups of girls who took religious classes on Saturdays. She had a friendly demeanor, and wore a long *khimar* that reached to her knees. Manal mentioned that they were not really in need of large funding because they were subsidized by so many people who wished to fulfill their *zakat* requirement (almsgiving, a requirement in

Islam). On one occasion, Salma exclaimed to me in English about the wide network of organizations with which al-Hilal worked:

> *You have to imagine how far our connections can reach and how intricately tied to each other our organizations are and how carefully run. Sherine, we are an empire!*

It struck me that she would choose such a term to describe religious organizations that were after all working for God's cause. It struck me too that she was describing to me an organization that competed in its size, goals, and administration with state organizations. These various Islamic centers were not only well connected but large in number, well funded and with hard working women laboring for them, but they were also providing services for the public that were often better, more stable, and more reliable than those provided by the government. So while the majority of the Islamic PVOs and NGOs did not espouse political goals, their ambitions were certainly challenging the state's authority and hegemony over public services. Yet the women who worked at the centers never spoke of their activities in this way. On the contrary, they were driven by a nationalist fervor that sought expression at times when, for example, political events that affected their nationalist sensibilities took place. Most Egyptians often regard themselves as Arabs, especially in times of crisis, and thus events in the Arab world are regarded with a measure of national feeling. Escalating events in Palestine and the deaths of children there elicited more than just the women's private expressions of concern. They actually held a large meeting where, I am told, many of the women arrived dressed in black and held a special Qur'anic recital over the deaths. Hundreds of women flocked to al-Hilal Mosque where this event took place, and the recital and prayers continued until late at night. Thus Islamic activism creates a forum of dialogue for women, not only for discussions about religious and social matters but also allowing for political views and nationalist concerns to find expression.

Salma's use of the term "empire" evokes significant interpretations. To think of the Islamic PVO of al-Hilal in those terms most certainly reflects on the magnitude of the establishment in Salma's eyes, and hence of course her role in it. It was never an easy task for the greatest emperors in history, so how then are these women, who are often disregarded as "oppressed,"

able to run empires as efficiently as they do? They most certainly face obstacles both ideologically and logistically: ideologically because women do not run empires in a patriarchal society, and logistically because women are a somewhat marginalized group in society with little access to the resources necessary for running organizations of this size. Islamic women, activists as I have shown in the previous pages, form groups that rely on strong bonds and they create financial sustenance through activities they generate themselves. But most importantly they forge identities that create a moral capital upon which they draw to pave more avenues to helping the less fortunate in society as a means of getting closer to God. As they invest their lives in the pursuit of their goals for higher religious attainment, Islamic women commit themselves to disciplines that reshape their bodies and spirit as they subscribe to the model of the Ideal Muslim woman.

Discipline and the Attainment of the Ideal

Within the core of women's Islamic activism prevails an important paradigm central to the roles that these women assume. This is the notion of the ideal, the vision towards which these women aspire, the image of the model Muslim woman. I will review here the Islamic notion of the ideal woman in Muslim Brotherhood rhetoric because I believe that it wields the strongest influence on the discourse and hence the self-discipline of Islamic women who seek self-enhancement. The Muslim Brotherhood publishes extensive material for the Egyptian Muslim public that provides guidance on how to conduct oneself in daily activities. The concept of *mo'amalat* (general behavior) verses *'ibadat* (meaning worship, rituals and carrying out the tenets of Islam) addresses the means by which a Muslim conducts herself/himself in all matters concerning daily life. Women receive their equal share of information, manuals and booklets that widely circulate in the market describing how women should conduct their *mo'amalat*. The first sentence in the booklet on women in Muslim society[12] reads as follows:

> A woman is a mother whom the Qur'an mentioned as having heaven under her feet... And a woman is a daughter and a sister who is born like

[12] Islamic Center for Study and Research, *The Muslim Woman in the Muslim Society* (Cairo: 1994).

her male brother from the same *solb* (source) and womb... And a woman is the wife, a home for her husband as he is a home for her....

The booklet goes on to describe the ways in which Islam has honored women, unlike other religions and ideologies that have debased and mistreated women. The ways in which women are equal to men are enumerated in the booklet, which begins to draw on examples of the famous women of early Islam such as 'Aisha, Noseeba Bint Ka'b and others. The purpose of that is to show that Muslim women were assertive and actually fought beside their men in the Islamic wars while nonetheless following Islamic teachings.

From a discussion on women's rights in Islam to Islam's gender complementarity, the booklet leads its readers towards the last section in the book on women's obligations. In this section, the first emphasis is on women's bodies, which should be covered excepting the face and hands. Women should exercise *haya*̓ (a combination of shyness and modesty) more than men. Women are not to be alone with strange men as that damages the woman's *haya*̓ more that the man's, because women should have more shyness and modesty. The following pages in the booklet emphasize women's domestic role as mothers, wives and nurturers and equates housewives with queens. This chapter ends with a clear reference to women's right to work, maintaining that the husbands and children's rights should come first. It ensures the well being of society as a whole if the family is in good form. The manual concludes by asserting that the *shari'a* gives the right to the husband to decide whether his wife may work, but only after the couple have discussed it between themselves. The state should not interfere in these relationships.

In accordance with the ideology of the Muslim Brotherhood on women's importance as the mothers who craft the young generations of Muslims, Muslim Brotherhood leader Mustafa Mashhur calls for women to contribute to the *da'wa*. Mashhur describes a detailed agenda for women that is largely applied by Islamic women activists today. In fact, as good Muslims, women are obliged to be active outside the home:

> Some men have false impressions that women should have no work other than the home and they (men) stand in between her and participation (outside the home). This view must be corrected. There is nothing to prevent (a) woman from understanding what takes place around her in the

Islamic realm. Whoever does not care about the condition of Muslims is not one of them.[13]

How then did this clearly articulated ideology sit with Islamic women's own? And how did women envision ways of becoming this image of ideal Muslim womanhood? The rest of this chapter will address women's means to self-improvement and heightened moral and virtuous standards as I understood these concepts from my fieldwork and interviews. First is religious practice, which is the ways by which women perfect *'ibadat*. Second, the way Islam informs women's *mo'amalat* and how women hone their inner selves through social practices to which they subject themselves in order to become closer to God. These include obedience to God and to the husband/parent, and conducting themselves with shyness and modesty. This also includes, according to my informants, their religious activism, which they see as one of the main ways by which they attain a purer inner self and allow for greater levels of religiosity.

Some feminist scholars have used the various dimensions of the pedagogy of everyday life to study their impact on the construction of gendered differences and identities.[14] The pedagogies of everyday life inform people in socially and culturally unique ways by sharing common experiences such as schooling, playing and television, and ways in which they learn manners and good behavior. Pedagogical principles are often informed by patriarchal ideologies, which in turn influence the concept of the "ideal woman" in society. With the growing Islamization of Egyptian society, many young girls have taken to wearing the veil. In the centers where I went to do my fieldwork, all girls between the ages of 7 and 15 were veiled. On several occasions I have heard women discuss veiling in connection with their daughters, mostly agreeing on the principle that it is better to make girls wear the veil when they are still young to avoid resistance from them later. Al-Hilal center holds a special party, *haflet hijab* (*hijab* party) where all the girls from the different centers are invited. The *da'iyah* Salma, whose 13-year-old daughter is veiled, described the

[13] As quoted in Layla Salim, "Al-Mar`a fi Da'wat wa Fikr Hasan al Banna: Bayn al Madi wa al Hadir" (Women in the Da'wa and Thought of Hasan al-Bana. Between the Past and the Present), *Liwaa al-Islam*, Jan. 1990, #52.

[14] Carmen Luke, Introduction" in Carmen Luke, ed., *Feminisms and Pedagogies of Everyday Life* (Albany: State University of New York Press, 1996) p. 4.

party and the pedagogical goals they hope to accomplish from such an event,

> Girls are invited to attend this event, which we hold in one of our largest centers on the outskirts of Cairo. We hope that in meeting other girls they will share their interests about Islam with each other and therefore become motivated to learn. The experience of meeting a girl who is donning the veil for the first time might also become of interest and may inspire the girls who are not veiled to wear the veil too. The celebration is a lot of fun. We sing special songs and the newly veiled girls wear a crown on their heads like queens, and we all congratulate and honor them. It is a great way to reinforce the importance of the Hijab as Islamic dress.

Foucault's description of disciplinary practices tied to pedagogical institutions centers on the processes of bodily activity and not merely on their results. The aim of these disciplines is "to produce subjected and disciplined bodies."[15] The religious institutions, in this case the mosque and organizations such as al-Hilal and al-Fath, act as centers of pedagogy to produce Islamically disciplined women. They define how women conduct themselves according to Islamic custom and *shari'a*. Sermons and lessons emphasize *ta'amolat* by means of which women should behave according to prescribed rules and sermons. Dress is clearly specified; talking, greeting, visiting, and entertaining receive special attention in religious lessons. Religious discipline, however, is a rigorous and painstaking process of tapping into one's inner resources and strengths to rise above the mundane of metropolitan life. Nadia, an attractive woman of 28, volunteers at al-Hilal to help distribute donations and *zakat* to the poor in lower socioeconomic level neighborhoods. Consider what she says below, in an account that echoes many Islamic activist women who describe the impact of *ta'amolat* (interactions) on shaping women's struggle with themselves to attain Muslim ideals in order to be closer to God:

[15] Sandra Lee Bartky, "Foucault, Feminism and Patriarchal Power" in Irene Diamond and Lee Quinby, eds., *Feminism and Foucault: Reflections on Resistence* (Boston: NorthWestern University Press, 1988) pp. 61-87.

> When I went to perform the pilgrimage with my husband and two other couples of friends it was like a dream come true. But while we were there and when we came back, all that mattered seemed to be the veil. The subject was so overemphasized by my friends and by the preachers who accompanied us that I burst out and told everyone to leave me alone and that I was not ready for it. Meanwhile as all the women who were with us wore the veil and I was the only one who did not, I kept debating with myself. Two years later, after I finished the evening prayers, I told my husband that I have made the decision. I would wear the veil. After that I felt calm and at ease with myself. It was like I settled a debate with myself once and for all. Now I have found the decision very comforting. I am satisfied that I am doing something which God has asked me. I feel much closer to Him as a result.

Foucault's processes of bodily discipline perpetuate the principles of modernity and science, but here, among the women I worked with, the ideology of "tradition" dictated the norms of the self. Thus, the ideal image of a Muslim woman as articulated by male Islamic discourse undergirds the various disciplinary practices of praying, fasting and Qur'anic recital. "Islamic prayer is performed five times a day," preaches *da'iyah* Sherine Fathi.

> It is a way of reminding ourselves of our obligations to God. As one prays regularly, one is ma'sum *(protected from committing)* from wrongful acts, because we remember we will stand between the hands of God for the next prayer. Prayer disciplines the self. When our watch breaks down, we send it to be repaired. Similarly, prayer restores our selves to God. Step by step. Don't rush things and don't judge yourselves harshly. Things will take their course and you will find yourselves getting closer and closer to God.

The ritual of Muslim prayer is a detailed procedure divided into steps or *rak'a*. As I stood to pray in the mosque of al-Hilal, a practice I had performed over many years, the woman next to me murmured under her breath that I should not fold my hands on my waist at the beginning of prayer. I took her point and the woman looked away, satisfied that she had done her duty, and began her own perfected prayer. Just as prayer disciplines the soul, fasting tames unchecked bodily desires. During Ramadan, Muslims abstain from food, drink, and sexual relations. It is a

time that stretches from sunrise to sundown, during which bodily discipline regulates the spirit of the Muslim and his or her control over the body. Once more, this is a practice that disciplines as it empowers. As the self is created through disciplines of subjection, it accrues power through the mastery of the disciplines. By perfecting religious practices such as prayer, fasting and subscribing to Islamically informed social and behavioral models, women reinforce mastery of religion in a society in which Islamism commands attention in the public sphere.

Gender Roles: The Domestic as Worship

The discourse on gender relations in both Islamic PVOs is preached and practiced according to a basic Islamic premise here explained in a sermon by *Doctora* Iman, who is the expert on women's issues at al-Hilal. All the women seek her out if they have questions or inquiries about *shari'a* or women's rituals. When I went to hear *Doctora* Iman at al-Hilal, I was surprised to see a larger attendance than was usual at the regular religious lessons there. The hall on the second floor of the building was packed with women. More started coming until they were standing on the stairs outside the hall: there were approximately 100 women crammed together. Eyes fixed on the *da'iyah,* they hung on every word. The mix of socioeconomic levels was of an extent I had not seen before. Besides the women dressed in colorful *galabiyas* (traditional long Egyptian dresses) from the very low class, I could spot the faces of women of the upper and upper middle classes whom I saw around the neighborhood driving their brand new cars and picking up their children from the most expensive day care. *Doctora* Iman was very much aware of this mix. As she sat on her chair surveying the crowd, she went on to say:

> Men and women are equal in the eyes of God and each has a clear and essential role to play in society. Men are responsible for women in the family and therefore have a supervisory role, if not an unconditional dominance over them. A woman by virtue of her central role in the family deserves that her needs and rights are met by the man, and vice versa.

Thus she emphasized the complementarity of the sexes and veered clear from discussing any class-related issues that I had noted in lectures given to a particular class as, for example, the theme that criticizes a focus on materialism and is designed for a well-to-do audience. In general, Islamist discourses emphasize the complementarity of gender roles rather than their equality, and the ultimate goal is the benefit of a harmonious Islamic society at large. Yvonne Yazbeck Haddad and Jane Smith explain a number of Islamist women's views on the subject as resulting from a firm belief in the justice of God, which conceives of equality yet difference between men and women. This egalitarian view of gender roles is directed at providing a balance in society while guaranteeing women's rights as decreed by Islam.[16] Haddad and Smith find that the issues of obedience to male authority are of a more complex nature. The notion of *shura* (consultation), which is the basic form of Islamic decision-making, prevails even in the home, with the husband acting as arbiter if consensus is not reached. They maintain that Islamists see a need for leadership for all social units, and as women carry the burden of childbirth men should be able to carry theirs as well. "This reality seems not to bother Islamist women as much as give them a sense of order and security."[17] Living this set of principles, Islamic scholar Heba Raouf Ezzat values her own relationship with her husband dearly. She describes it as an intimate connection between two equals in which final arbitration has to be facilitated through one person, often her husband. As she honors his needs, he too understands hers, and consequently he helps with housework or turns a blind eye when things are a bit messy.

The discussion of gender roles leads Haddad and Smith into the subject of work as defined by an Islamist women's agenda. Their findings corroborate those of Zuhur concerning the pronounced need of Islamic women activists to balance domestic duties with outside work when work is a necessity. Sherifa Zuhur draws our attention to a salient point in this debate by writing that, in many cases, women who agree in principle to what their Islamist leaders argue in practice give precedence to the pressing economic needs of day-to-day life that often necessitates a direct reversal of what they still perceive as the Islamic ideal. In this regard, Zuhur maintains that women who may criticize other women who work and those who use

[16] Haddad and Smith, pp.137-150.
[17] Ibid, p. 144.

outside child care may resort to these very means of survival when the need arises despite an awareness of their less desirable consequences.[18]

As *Doctora* Zeinab often points out in her teachings, paid employment is not the only type of work available to Islamic women. Haddad and Smith relate that Muslim Brotherhood teaching has recently started to encourage women to participate more actively in the development of their countries through projects that promote the welfare of its people. They describe Islamic activism of the type described here, adding that this is a growing phenomenon in the Muslim Middle East today in countries such as Kuwait and Qatar, Tunisia, Morocco, Jordan, Syria, Iran and Egypt. Duval mentions the leader of the Islamist group Zahra in Egypt as saying,

> We as Muslim women should get prepared and equip ourselves with knowledge to preach Islam. Muslim women should not sit for hours in front of the TV. Our main concern should be *da'wa* (prosletization) to preach Islam and invite other people to Islam, not to watch *The Bold and the Beautiful*.[19]

Sheikh al-Qaradawi, a well known Islamist in Egypt, says,

> Women's servicing of their husbands is kindness as God ordained it... As for the entertainment of women by the man carrying out household duties—sweeping, mixing, cooking, washing, etc.—this is not kindness.[20]

Linking domesticity to a love of God once more qualifies it as an act of worship, a bodily discipline that, as it disciplines the body, contributes to constructing that ideal image of the Muslim woman.

I attended religious lessons given by one of the most famous woman in al-Hilal organization, Sherine Fathi. Fathi was a woman in her late 40s, who graduated from medical school and gave up her job as a doctor after years of marriage because she believed she was overextending herself. She maintained that she could not be "faithful" to both jobs at the same time, a mother and housewife or a doctor. Her sermons (two of which I attended at al-Hilal and another in a mosque in Nasr City) were always crowded with women of different ages and backgrounds. They were mostly in their late

[18] Zuhur.
[19] Duval, p. 60.
[20] As quoted in Karam, p. 193.

thirties to forties, but often included teenage girls. Each sermon was organized and run by a team of women, some ushering in the audience and others distributing small booklets of Qur'anic verses, which the *da'iyah* was interpreting. Two of them seemed to be in charge of logistics, such as the sound of the microphone, switching on the fans, making announcements and so on. Fathi is always very well spoken; she articulates her points well and knows when to pause for effect and when to raise her voice to make a point. On this particular day, she was discussing women's duties and rights in Islam. As I looked around, the women in the audience were writing furiously, nodding their heads along with some of Fathi's starkly realistic comments. Her speeches always referred to familiar examples and she often inserted anecdotes and jokes into her sermons:

> Women are not expected to "enjoy" these [domestic] duties, but then, who would?

She gives the example of a woman who prepares a meal for her family as performing a religious duty:

> It is a form of love for God. Each laborious task she undertakes, every stuffed vine leaf she meticulously rolls is not wasted, because in the end it is an act of worship.

Fathi went on to encourage women toward activism by saying:

> As women you need to be vigilant. You need to have awareness of what is out there. Don't keep yourselves so involved inside the home that you are distanced from what your husband and children experience every day. To be a good mother and wife you also need to involve yourself in the world around you.

A clear attempt at striking a balance between women's activism and their domestic duties is highlighted in most of the sermons, which deal specifically with women's issues in the marriage and the family at both al-Fath and al-Hilal. In a lesson to a group of forty women from the lower socioeconomic level, *Doctora* Zeinab at al-Hilal also motivated women to pursue an active life.

> *Women are a positive force in society. I am against keeping women at home, doing nothing but housework and tending to husbands and children. That too is important of course, but in order to be more effective in their roles at home, women have to have different dimensions. If women were to stay completely at home, how are they to prepare their children to deal with modern day problems like drugs? How can they have good relationships with their husbands if their day was spent only cooking and cleaning? No, I really see women as instrumental in dealing with today's problems of poverty and ignorance.*

In response to a question about the economy and lack of employment, she said:

> *Why can't both men and women work? There are so many different opportunities for women to be productive. Work is not just employment for a wage, it can also be voluntary or charity work.*

As she dealt with the issue of marital conflicts she stressed the importance of religious duties as reciprocated between husband and wife. Although she maintained that a husband and wife have to abide by the duties articulated by Islam, she assured her audience that Islam does not condone wife abuse. *Doctora* Zeinab advised women to know their religion was protection from such injustice and to enlighten their husbands as well. She constantly emphasized the importance of *sabr* as opposed to what she termed the drastic measures of divorce that have dangerous outcomes for children. Thus, knowing one's rights protects women against abuse. However Muslim women need to practice restraint and *sabr* against injustice and are taught not to rush to drastic measures to deal with their problems.

A Sense of Empowerment

> *Our kind of activism motivates and improves women's sense of community. It provides them with a different kind of work through which they can discover their skills. It brings out the best in people. I have been through all that, I remember when I just started and didn't know anything. I signed up to learn how to recite the Qur'an. From there I decided to learn* fiqh *(jurisprudence) and when I passed my exams with Doctora Zeinab, I felt I had done something which took me a notch over many others who were still gossiping and talking about mostly nothing over at the Club. Now I knew I had a goal and a mission. Friends, students and acquaintances call me at home. They ask, "Salma what should I do with this or how should I perform this prayer or solve that problem with my husband or other?" It definitely makes me feel "empowered." When I am sitting in a social gathering with other women and they are discussing their latest trip or something or other, I have to tell you, I just feel that I am so much past these trivialities. I am so much better inside.*

Salma's sense of empowerment was, as she said, related to her sense of achievement and success at self-enhancement. She proceeded to relay how she undertook a strict disciplinary attitude towards her sense of religiosity. God and Islam acted as a constant frame of reference to her in every action of the day. Salma explained that she set high standards for herself because she was a *da'iyah*. She was reluctant to talk about her empowerment as we discussed the various manifestations of the concept in her opinion. Some minutes into our discussion, Salma said:

> *You know if it weren't for the fact that this concept is so important to you, I would never mention this to anyone. Saying that I am empowered is in direct contradiction to what I represent as a* da'iyah. *My duty is to be modest and unassuming. It is true that my religious role gives me a sense of power and achievement compared with those who involve themselves in trivialities, but talking about it should just not be done. It is against the spirit of Islam.*

I had a similar discussion with Maha, a woman in her forties, a wife and mother who graduated at the top of her class and worked for a while as

an assistant professor before moving into banking. Maha now dedicated her time to helping at al-Hilal. Poised, elegant but unassuming, Maha was an Islamic activist who in her own right had managed to create many improvements in people's lives. I watched this woman work patiently with adolescent girls, teaching them literacy. She often came into the center with arm loads of things for the poor, and on a weekly basis visited a number of families to deliver money and goods and make sure they were not in need. I talked with Maha on many occasions, and she often guided me on issues that included women in Islam, how Islam viewed abuse and divorce and many more. This time I asked Maha how she would feel if she had to give up her activism. She looked taken aback, as if the thought never crossed her mind until this moment, and then she said,

> *It will affect my relationship to God. If I do not perform these acts of kindness, it will sever a strong link to God. I cannot see my life without this. This (activism) is a reward that God has sent me. I would feel deprived from a privilege that I tremendously enjoy to help others and to attend to their needs.*

Thus Maha interpreted the satisfaction she derived from Islamic activism as a privilege that God had granted her. The absence of a notion of an agent who pursues a deliberate and conscious attempt at actively seizing opportunities to instigate change and placing this agency instead in the hands of God is a characteristic of Islamic women's activism. Any empowerment, therefore, that emanates from these activities is not understood in this rationale as a direct consequence of the action, but rather as borne out of the religious experience. Using the word in English, I asked Maha what she thought of "empowerment" and how she interpreted it. She immediately answered that many of the Islamic activist women enjoy positions of authority, such as *Doctora* Zeinab, Sherine Fathi and others, but that these situations developed as these women succeeded in achieving high levels of religious knowledge and as they themselves became role models to others who respect and admire them. But Maha here was using "empowerment" to mean power over others in a sense of authority. Salma was using empowerment to mean a higher level of self-confidence and assurance. However, neither of them saw empowerment as a goal of their Islamic activism. Rather they saw it both as a natural outcrop of religious

duty as well as of activism. "These women do not covet power. What they seek is a religious perfection that will bring them closer to God," Maha explained. This image of religious perfection is, however, defined and articulated by discourses that are produced by patriarchal sources of Islamism.

Finding Space for Empowerment

In providing Islamic services to widows, the women at al-Fath diligently worked every day to support entire families to make ends meet. I attended one of the monthly sessions when donations of food and clothing were distributed to the widows. The kind of poverty the activist women were fighting against and the constant numbers of the poor that the little organization dealt with again made it appear as though they could not be handled by such a small group of women. The scene I arrived at one afternoon in al-Fath was an incredible sight. The two rooms were being bombarded with women from levels of extreme poverty. They were all talking at once, waving pieces of paper in the air and demanding to be let in to receive their monthly rations. The Islamic women of al-Fath were seated behind long tables as they proceeded to examine each of the women's tickets (which entitled them to the rations) and crossed their names from a list. Things became so chaotic and so unbelievably loud that *Haga* Amira called out in a voice I had not heard before, "Everybody out! I am not giving any more money if you (women) do not stand quietly and in line!" At which she went into one of the rooms with *Haga* Sanaa, who was helping her, and they closed the door. Once silence had descended on the women, both *Hagas* came out again and resumed their task in a more orderly fashion, yet still with some difficulty because of the narrow space in front of the rooms in which they worked. The area that they had was so tiny that I was compelled to ask why they did not use the adjacent space provided by the courtyard of the mosque of Abu Bakr. *Haga* Amira replied that they could not because that area belonged to the men. She continued to recount the difficulties they had been having with the men who ran the mosque. Not only were the men not helpful, but they assumed an antagonistic attitude to their presence. *Hag* Abdel-Samad, the mosque keeper from next door, had even reported them to the police, complaining

that they collected a lot of money from the charity bazaars and accusing them of embezzling the money for themselves.

Haga Amira surmised that the men had become jealous when they noticed how much success the women's organization was having. She mentioned that *Hag* Abdel-Samad had come over and actually demanded that the women share the funds they raised with the men. The women were upset and did not know how to deal with this situation. So, after some deliberation, they decided to pack up and find somewhere else for their small organization. After searching all over the neighborhood, they found a perfect place on top of a little mosque in a garden and shady area next to a police station a couple of streets away. At my look of optimism, *Haga* Amira shook her head and said that the men found out and actually went to the *sheikh* of the other mosque and told him more lies about them. So the women were turned down by the new mosque and had no choice but to go back to their old place, but this time they were determined to end this problem once and for all.

Haga Amira and a couple of the others went to pay a visit to the men and chided them for creating problems for perfectly respectable religious women who just wanted to help people and who were officially registered with the ministry. *Haga* Amira recounted how the men denied their accusations and said that they all worked for God. In conclusion, however, both sides decided to live amicably, especially after *Haga* Naguiba contributed LE500 from their funds to the men's mosque. Nowadays, she said, they avoided confrontations although many sinister undercurrents ran between them.

The conflict between the men and women in what *Haga* Amira recounted was related directly to religious space. The women antagonized the men by occupying the space in what had previously been a male-dominated area. The men had hoped to control this group of women by demanding that they share in their profits in return for allowing the women to do as they pleased. When the women refused the men decided to make things difficult for them. However, by addressing themselves to the men from within the frame of Islamic discourse as "perfectly respectable religious women," they ensured the men found it difficult to contest them, particularly since the women had developed a strong reputation of being virtuous through their various activities. In the end, when it became

obvious that they could not contest the integrity of the women, the men were forced to admit that they were all working for God. The closure of the story is also of interest. The women sealed their negotiation with the men by contributing to their cause, but this time they did not do it as an act of acquiescence but as an act of faith represented by almsgiving. By donating the money, they effectively placed the whole situation in a religious frame, inscribing themselves with an air of being the "better Muslim" who contributed to religious causes.

Islamic activism thus redefines not only women's but men's space. As women become more religiously active, men's monopoly over the public religious domain is challenged. However, through the various forms of activism and charity work that they do, through honing themselves by ritual and acquiring a good grasp of Islam, Islamic women assert their claims on their newly found space. By conducting themselves to the ideals of men's Islamic ideology, women subject themselves to rigorous measures of self-discipline and moral standards of public behavior. Through what Michel Foucault calls the "technologies of the self," a concept I will employ in the following chapter to show how women attain notions of Muslim idealism, I will argue that women find empowerment through gaining legitimate social space from whence they enable themselves to impact the lives of others in need and hence to become better Muslims.

In this chapter, I have explored Islamic women's activism and its relationship to notions of the "ideal Muslim woman" in society. I have illustrated how women define their social identities, how they construct structures that afford them support and solidarity and how they employ these structures in defining space and creating legitimacy. The participation of these women in pedagogical disciplines that, while subjecting their bodies to disciplinary "technologies of the self," crystallized an empowerment based on patriarchal notions of femininity as articulated by Islamist male ideology. Islamic women described an empowerment that is a method or tool to religious perfection rather than an end in itself. The following chapter will engage in theoretical explorations to bring to light the central paradigms that have contributed to my analyses of the impact of an Islamic activism on women's empowerment.

CHAPTER FOUR

THE TERMS OF EMPOWERMENT

Studies concerned with women's empowerment in Arab Muslim countries have observed with alarm that women are joining Islamic movements that are often equated with fundamentalism. Islamic women activists are often represented as women who "buy into the very discourses which subjugate them,"[1] and are described as parroting their male leaders, assuming leadership only under male supervision and command.[2] My fieldwork shows that the Islamic women I encountered as friends and informants did not fit comfortably under those descriptions. In this chapter, I question some of the theoretical approaches that address women's empowerment to drive at an understanding of the impact of Islamic women's activism on women in Cairo. How is it possible to interpret the impact of Islamic activism on the empowerment of women? My goal in this chapter is to examine theoretical frameworks dealing with power and notions of self-empowerment that encourage a consideration of alternative forms of empowerment other than those informed by mainstream liberal principles. What does empowerment entail for Islamic women activists? How can prevalent theoretical frameworks on power in feminist literature help interpret women's empowerment in the contemporary Islamic sense?

Islamic women activists posit two theoretical problems in an analysis of empowerment. First, they belong to a tradition—Islam—that is perceived as being oppressive to women. Generally interpreted as a patriarchal religion that favors males over females, they fit into a feminist criterion of oppressed women. Second, Islamic women activists endorse a gender ideology that is not predicated upon universal feminist norms viewing gender equality as means for women's empowerment. Instead, they emphasize in their daily

[1] Hanna Papanek, "The Ideal Woman and the Ideal Society: Control and Autonomy in the Construction of Identity" in Valentine Moghadam, ed., *Identity Politics and Women* (Boulder: Westview Press, 1994) pp. 42-75.
[2] For a review of these perspectives, see, Barbara D. Metcalf, "Women and Men in a Contemporary Pietist Movement: The Case of Tablighi Jama'at," in Patricia Jeffery and Amrita Basu, eds., *Appropriating Gender: Women's Activism and Politicized Religion in South Asia* (New York: Routledge Press, 1998) pp. 107-108.

activities their religious zeal, virtue and high levels of moral ideals as prescribed means to self-enhancement. As Islamic women preach modesty and obedience and emphasize feminine roles, they exemplify the very qualities that feminist theorists call for replacement with independence and freedom from oppressive traditions, sexual liberty, and freedom from gender discrimination.

I am arguing that Islamic women create alternative forms of empowerment while remaining embedded within structures that appear to support their domination. They develop a sense of "empowerment" predicated upon Islamic criteria that challenges Western liberal frameworks of analysis. This is because while they submit themselves to structures of authority that privilege men, they paradoxically empower themselves in dealing with men by acting in accordance with prevalent norms of ideal female behavior. Foucault's theory of the "relational individual" in which he described the formation of the subject not as a free autonomous agent, as liberals do, but as an agent who succeeds relations of power, offers a useful language for my analysis. According to this view, the subject is not merely subjugated in relations of power, but is also formed by power. Islamic women activists realize their empowerment from "within" the relations of power rather than from an external position that directly challenges it. Crucial to this analysis are in particular the contributions of Jill Butler, Talal Asad, Suad Joseph, and some of the extensive literature generated by development projects for women.

I will begin by considering notions of empowerment, which have characterized the field of women's development to illustrate how practical fields define empowerment. This will be followed by alternatively considering Foucault's work on subjectivity, followed by Butler's modifications and Asad's critique of consciousness. The chapter will conclude by linking the theoretical postulations that aim at explaining Islamic women's empowerment with the historical specifications that created the context for this empowerment for women.

From Development To Empowerment

Empowerment has become a commonly used term to refer to the ability of an individual to be *enabled*, i.e. to be free to exercise his or her power in decision making and in making choices that shape the individual's future. The empowerment of women is becoming an increasingly popular term in human rights and development discourse, as well as the terminology of NGOs, the UN, and various fields of research studies on women all over the world. Despite the universality of the term, however, few attempts have been made toward developing a definition of empowerment. One study that makes such an attempt, by Oxaal and Baden, provides an extensive survey of development organizations and NGOs to reach at the roots of the term, its usage, implications, and indicators.[3] The authors maintain that the putative origin of the idea of empowerment as a notion that emerged from the Southern states cannot be readily sustained. The word is problematic and ambiguous. It is not easily translated, nor does it exist in most languages. According to Oxaal and Baden, it is thus most likely that the notion of empowerment is derived from the birth of the idea of Western individualism.[4] The roots of empowerment lie in longstanding concerns in development literature. "Power" itself, however comes in diverse forms:

Power *over* Relations of domination/subordination are implicated here. It is based on socially sanctioned intimidation and invites active and passive resistance.

Power *to* A creative and enabling power that is related to decision-making authority.

Power *with* Centers around the organization of people to achieve collective good.

[3] Zoë Oxaal and Sally Baden, "Gender and Empowerment: Definitions. Approaches, and Implications for Policy (report 40)". Briefing prepared for the Swedish International Development Cooperation Agency (Sida), 1997.
[4] Ibid, p. 4.

Power *within* Refers to self-confidence, awareness and assertiveness. It is concerned with the way individuals can recognize power dynamics in their lives and learn to influence and change it.

According to this categorization, when development projects seek to "empower women" they address certain criteria that enable women to achieve a state of empowerment. In general, the criteria for women's development include participation in decision making processes, as well the creation of an awareness among women that they may be entitled to occupy a decision-making space in the public sphere. In this view of empowerment, making choices and the ability to shape available options is also central to development aims. Most significantly, many development projects admit to the inevitability of involving conflict in a redistribution of power. Power is generally articulated as a "possession" that is possessed by individuals and determines whether they are dominant or oppressed. The Report of the UN Fourth World Conference on Women, which called its Platform for Action "an agenda for women's empowerment," maintained that: "…the principles of shared power and responsibility should be established between women and men at home, in the workplace and in the wider national and international communities."[5] As a common paradigm, "Empowerment corresponds to women challenging existing power structures which subordinate women".[6]

Central to this vision of empowerment, which has gained impetus in development discourse, is the notion that power belongs to the individual rather than the collective. Entrepreneurship and individual self-reliance rather than cooperation are emphasized as means of challenging power structures, which are seen as subordinating women. This view, Oxaal and Baden point out, is derived from a belief in entrepreneurial market capitalism as a rescue measure for ailing economies and the retreating state subsidy of social welfare, employment, health and educational services. Clearly, development goals for women's empowerment are predicated upon

[5] UN, 1995, *Report of the Fourth World Conference on Women*, Beijing, China, in ibid, p. 4.
[6] Ibid.

liberal approaches to democracy, which promote individual freedom, rights and participation in decision making through the electoral process.

Understanding Notions of the Self in the Middle East

In the general liberal sense, the individual is seen as an autonomous, free and contractual person.[7] This conceptualization follows from the struggles of women within Western structures of power. In European and American societies, women were marginalized from the process of political participation through the classical liberal view of the individual. Women in the West accordingly struggled to find a place for themselves in a social world where power was identified with autonomy, independence, and rights freely to construct legal relationships. But such a concept of self is by no means universal. Liberal views of the individual are not adequate in considering the self in a region such as the Middle East. An understanding of the self should not be contingent with the concept of the individual as an autonomous, bounded, and free entity but rather on a complexity of relationships, which mediates the construction of the self in this part of the world.

However, this is not to say that a single notion of the self exists in the Middle East today, where there is a wide diversity of social structures that influence people's relations to one another and their ability to become empowered agents. Furthermore, a notion of agency—in the liberal sense—ignores circumstances, while assuming a certain consciousness that directs itself according to relations of oppression/domination. Talal Asad, for example, is critical of such approaches because of what he calls "structural exclusion." Asad maintains that agency is inadequate in explaining the subject in the repression/domination sense, as he explains that constricting conditions may deal a heavy hand:

> It is more like the situation in which one considers the kinds of move possible in a game of chess in which you oblige your opponent to make certain moves and prevent him/her from making other moves. In other words, there are certain circumstances and conditions which may or may not be immediately available to the consciousness of the person engaged in those activities but which constrain and structure the possibilities of

[7] Pateman.

his/her own actions. ...This doesn't mean, of course, that people have no consciousness. It means that we are looking at the wrong thing if we look to consciousness to understand the changing patterns of our lives. For that, we ought to be looking at the circumstances by which possibilities are patterned and re-shaped which constrict action or its potential.[8]

Debates over women's power in Middle Eastern societies have also been enriched by problematizing the issue of the self in complex relationships of connectivity, love, and power. In studying Lebanese society the work of Suad Joseph, which emphasizes connectivity, directed studies in the field at examining the intricate processes by which the Middle Eastern patriarchal system reproduces and is reproduced. Patriarchal relationships of connectivity shape exchanges of love and power between males and females in kin-based contexts that ultimately translate into male dominance over society as a whole. Joseph proposes an understanding of a notion of the self based on her concept of "connectivity," which challenges claims that a single liberal notion of the individual is sufficient for understanding all notions of the self Middle Eastern societies. In her work, she describes connectivity as a psychodynamic process of intention (rather than being) by which one person can see her or himself as part of another person:

> Boundaries between persons are relatively fluid so that each needs the other to complete the sense of selfhood. One's sense of self is intimately linked with the self of another such that security, identity, dignity, and self-worth of one is tied to the actions of the other. Connective persons are not separate or autonomous. They are open to and require the involvement of others in shaping their emotions, desires, attitudes, and identities.[9]

It therefore follows that in analyzing the impact of Islamic activism on women in Cairo, it is important to take into consideration that normative notions which view Islamic women as singularly individual, free and autonomous, whose selves are fixed and whose actions are affected by their social and historical context only through free "choices," would be distortive. My examination of the historically and culturally specific dynamics in Chapter Two have therefore helped contextualize the Islamic

[8] Mahmood.
[9] Suad Joseph, "Brother/Sister Relationships: Connectivity, Love, and Power in the Reproduction of Patriarchy in Lebanon," *American Ethnologist*, vol. 21:1, 1994, p. 55.

women I study. To reach an understanding of empowerment that takes account of the fluid selves of these women I am studying, I will provide an analysis of the psychological, social, and cultural processes that engender their sense of self in what follows. What appears even more relevant to this study is the way power is mediated between male and female, such as Joseph portrays in the relationship between brother and sister. In the way, the brother wields power over his sister, which is legitimized by social and cultural ideology as well as by brother-sister love. As the brother was responsible for his sister's behavior, the sister was expected to accept her brother's wishes. His dominance over her resulted from her subjection of herself out of love and belief. But that is not where it ends, according to Joseph: the sister also wielded power in this relationship,

> Through the brother/sister relationship, men learned that loving women entailed controlling them and women learned that loving men entailed submitting to them. Sisters also had some power over brothers. Women had numerous avenues for involving their brothers in their lives. Because a woman's behavior immediately reflected on her brother's honor, dignity, and sense of self, *she could enhance or detract from her brother's status by her actions and potentially compel her brother into action.*" [10] (emphasis mine)

I similarly argue that women are not merely subjugated in relations of power, but are also empowered as a result of the dynamics in these relationships. Islamic women activists find an empowerment from "within" such relations of power by subscribing to notions of Muslim ideals for women.

According to feminist theory, the central theme on which an ideology for women is formulated is the necessary premise that men and women are equals. Theory is concerned with analyzing the relations of power based on equality and parochializing difference. Feminists caution against emphasizing gender differences, since this will inhibit an analysis of power, as power can be masked in arguments over "difference."[11] Meanwhile, the Islamic women I interviewed posited varying viewpoints about gender relations, and many even did not consider the matter an issue in Islam. The

[10] Ibid, p. 56.
[11] Jane Flax, "Postmodernism and Gender Relations in Feminist Theory," *Signs*, vol. 12 :4, 1987.

majority of the women I interviewed saw that God created the female and male to complement one another, to fulfill different roles in society that are outlined in the Qur'an. Islamic women *da'iyat* do not converge on the issue, but they are clear on the fact that men and women are different. They view the relationship between wife and husband to be based on responsibilities as well as obligations that are clearly outlined in the Qur'an so that a harmonious and equitable relationship prevails in the family and both partners enjoy the rights Islam has decreed for them. Islamic women scholars, however, elaborate on the issue of roles in that many of them maintain that the Qur'an never restricted roles based on gender. These scholars argue that motherhood, though most certainly an honored position in the Qur'an, was never presented as a sole option for women.[12] The fact that Islamic doctrine maps out gender roles for human beings and articulates rights and responsibilities based on these roles affects therefore the roles that people play in society and engenders a measure of empowerment that is influenced by its gender ideology. A theoretical paradigm that endorses an independent and autonomous individual who is free to choose an identity and lifestyle regardless of the social fabric in which he or she lives, as proposed by liberal modernists, is therefore inadequate in critically analyzing an empowerment for women whose world views are not consistent with this type of ethos. Clearly, a consideration of empowerment that regards its subject as created by social relations and not as autonomous from them will provide a more lucid understanding of the impact of Islamic activism on women's empowerment in Egyptian society today.

A Foucauldian View of the Self

The ideology of Western liberalism that preempts free will to an agency that is largely independent from a world in which it must negotiate its identity is radically undermined by the Foucauldian view of the self. Foucault is said to liberate the concept of power from political theory in order to study it up close in the microlevel of society.[13] Rather than follow the paradigm that views power as repressive, a view that does not account for the strong grip

[12] Wadud-Muhsin.
[13] Jana Sawicki, *Disciplining Foucault: Feminism, Power, and the Body* (New York: Routledge, 1991) p. 20.

power structures have on human beings, he sees power as productive. Institutional and cultural practices in society, he argues, through their disciplinary character, empower even as they subjugate the individual. Foucault explains that disciplinary practices are authoritative and effective in their normalization to the extent that they are able to control and create divisions among people, and this includes labeling in society. Feminists use Foucault's "bottom-up" approach, which calls for a type of resistance at the level of everyday social relations, as a helpful paradigm when addressing effects of domination such as patriarchy. Whereas Foucault's work undermines the monolithic view of patriarchy, it nevertheless asserts an understanding of social formations as masculinist. Some feminists regard this innovation as useful in enabling women to step away from the disempowering notion of their oppressed selves against the hegemonic dominance of male patriarchy; thus women are "freed" to resist local struggles and to focus on specific issues rather than attempting to battle with an unbeatable force.[14]

Concepts of patriarchy however, are dissimilar in Middle Eastern and Western societies. In the former, patriarchy generally describes kinship structures in which males have authority over women, and older males over juniors, in institutionalized forms that legitimate patriarchy as a social system that permeates the lives of its members. In the latter, patriarchy is defined more as a system of institutional inequalities and unrelated to kinship.[15] In a novel perspective that addresses the need to situate women's struggles for their rights in the family, particularly in the Middle East and Saudi Arabia, Soraya Altorki argues that women can and do increase what she calls "their strategic capital" through kinship structures. Altorki argues that the central role played by the family in the region affords women "a moral authority as mothers and nurturers" from whence they are more likely to produce a favorable impact on their status, since this is a position that does not challenge the strong patriarchal system that permeates social and political life in Saudi Arabia.[16] While in her article Altorki clearly

[14] M.E. Bailey, "Foucauldian Feminism: Contesting Bodies, Sexuality and Identity" in Caroline Ramazanoglu, ed., *Up Against Foucault* (New York: Routledge, 1993) p. 119.

[15] Michel Foucault, *Discipline and Punish: The Birth of the Prison* (New York: Vintage, 1979).

[16] Altorki, "The Concept and Practice of Citizenship in Saudi Arabia", p. 234.

delineates the injustices patriarchal traditions have incurred on women, she maintains that the marginalization of women's status in the kingdom of Saudi Arabia is due to particular interpretations of Islamic texts and not from Islam per se. The need to reevaluate our understanding of women in Middle Eastern patriarchal systems and women's empowerment therefore necessitates a reconsideration of patterns already existing in society that have been judged by paradigms informed by liberal conceptions of individuality and citizenship to be damaging to women.

Inspired by Foucault's work on the subject as formed through relations of domination, feminists embarked on a Foucauldian genealogy of gender relations. They began by observing the relations of male to female as a continuum of relations between the oppressor and the oppressed as opposed to seeing them as dichotomies. This has tended to obscure the more complex arrangements of gender relations such as those inherent in Foucault's notion of power as both subjugation and empowerment of the self. Jana Sawicki sees feminists who employ Foucault's work as falling into two categories: the first employs Foucault's analysis of the power of disciplinary practices as technologies that fashion women as subjects and as objects of knowledge. The other group considers domination as well, but focuses on strategies of resistance to hegemonic systems of power/knowledge. As an example of the application of Foucault on disciplinary measures as means of subjugation and subjectification, Sandra Bartky examines the complex of fashion and beauty in America, while Susan Bordo analyzes the cultural implications of anorexia nervosa. Bartky represents the specific forms of feminine embodiment that discipline the body, such as dietary regimens, expert advice on color coordination, etiquette, and style. She shows that while these technologies subjugate women because they confine women to normative identities, i.e. sexual attractiveness, women adhere to them as they impart skills and attitudes that when mastered imbue them with agency. Thus women are subjugated by patriarchal powers that tie women to specific paradigms of femininity. [17] Iman Farid Basyouny also explores the impact of these paradigms on

[17] Sandra Bartky, *Feminism and Domination: Studies in the Phenomenology of Oppression* (New York: Routledge, 1990).

women who submit themselves to the rigors of dieting and in clinics in Cairo.[18]

Feminist scholar Judith Butler makes direct connections between Foucault's notion of subject and power formation and gender issues. Building on his notion that the subject/agency does not precede but follows power relations, she argues in a psychoanalytical sense that subjection is instrumental to subject formation. In her book, *The Psychic Life of Power,* Butler defines "subjection" as the process of being subordinated by power and also the process by which the subject is formed. To her the subject encompasses the notion of the individual by acting as the condition for the formation of its existence and agency. As power is a subjugating constitutive of the subject, the acquisition of power is not a final appropriation. In fact, according to Butler, power must be reiterated in the site of the subject through a process of repetition that is never mechanical. Hence, conditions of subordination are not static, not frozen in time, but are constantly shifting gears as the agency of the subject is in effect the product of its subordination.[19] Butler's paradigm is therefore illuminating to the processes that create empowerment for the Islamic women activists whom I have studied, who as they subscribe to patriarchal ideals of womanhood, adopt religious practices that seem to be subjugating them. In doing so, they enhance themselves with skills that, in many of their conversations with me, they insist make them better people. Hence, one can reach an understanding of empowerment as derived from processes that simultaneously subjugate women and also endow them with power as they gain higher levels of respectability, legitimacy, and personal satisfaction. From what they describe as a continuous process of self-improvement and perfection through overcoming everyday challenges posed to their sense of religiosity and heightened morality, they are in essence reproducing relations that subjugate them by employing their ideology and newly found skills to overcome these challenges. In the next chapter, I will describe the ways in which Islamic women expressed their notion of acquiring an inner self-empowerment. Women described themselves as occupying a higher status

[18] Iman Farid Basyouny,. "*Just a Gaze: Female Clientele of Diet Clinics in Cairo,*" *Cairo Papers in Social Science*, vol. 20, monograph 4, winter 1997.
[19] Judith Butler, *The Psychic Life of Power: Theories in Subjection* (California: Stanford University Press, 1997).

than others who have not reached their levels of religious refinement and attested to their recognition of their self-empowerment.

Butler and Foucault advocate a study of power relations rather than *of* power itself, which would emphasize how subjects are constituted by power relations. Both see power as productive rather than repressive, and challenge liberal views that preempt agency before power in their notion of an individual endowed with freedom, rights, and choices. As mentioned earlier, it has often been the case that by employing liberal notions of agency (which undermine the preemptedness of constitutive power relations) and feminist theory, Muslim women are often judged to be severely oppressed by religion, which is seen as a patriarchal system existing outside of them. However, by building on Foucault's and Butler's analyses of the formation of the subject, I argue that women's submission to male domination as exemplified in their ideology of the ideal Muslim woman as virtuous, moral and pious is, in fact, empowering their "selves." In this light, the dialectic relationship between genders in society is consequently seen to engender power and subjection of the self, which both Foucault and Butler reason are necessary for subject formation. Religion, which is often seen as repressive to women and favorable to men, provides Islamic women activists with what Foucault calls, the "technologies of the self."[20] He defines those as the means by which individuals submit themselves to discipline in order to reach certain ends.[21] It is in this type of discipline of Islamic teaching that women attain skills and attitudes that, while normalizing women's gendered subordination, also contain the ideals of feminine behavior in Arab Muslim societies. This produces an interesting parallel with Sandra Bartky's study of patriarchal control of women in Western societies by normalizing "sexual attractiveness" as being the desirable attributes of women. In a predominantly Muslim country such as Egypt, however, and especially in Cairo, as I have shown before, the rise of Islamism in recent years also posits its own discourse on the desired attributes of Muslim women, which represents the model women attempt to cultivate through their activism: faith, virtue, morality, modesty, and closeness to God. The women I worked with demonstrated that their religious zeal had an impact on many aspects of their lives. In the previous chapter, I described the practice of this religious

[20] Foucault, "Technologies of the Self," pp. 16-50.
[21] Ibid, p. 18.

zeal. In the following and final chapter, I will describe some of the ways their piety extends their empowerment beyond these institutions into everyday life.

I agree with Bartky when she contends,

> To overlook the forms of subjection that engender the feminine body is to perpetuate the silence and powerlessness of those upon whom these disciplines have been imposed.[22]

This study hopes to reveal that the real silence that has been perpetuated around Islamic women is that projected by liberal feminist paradigms that have not been able to translate the meanings of these women's voices. My objective is to break this silence by letting them speak for themselves.

[22] Bartky, p. 65.

CHAPTER FIVE

RESEARCH FINDINGS AND CONCLUSION

> With regards to women, they should act as care givers for their homes and attend to their husband's affairs and be aware of their neighbors' rights. As to working as a *"da'iyah,"* this is 'futile.'[1] If the woman has [learned] religious theology from childhood, it is possible to ask for her input, but only in matters that deal with women... But to work as a 'preacher,' that is the degeneration which religious and intellectual ignorance has dragged us into, as well as the absence of specialized scholars. That is why many go to those rowdy "preachers." And, unfortunately, people like to sit and hear [their] ramblings.
>
> Dr. Mohamed Abdel-Sami' Gad
> Dean Emeritus of the Faculty of Preachment, al-Azhar University[2]

Thus, in a succinct and decisive article that appeared in the popular *Rose El Youssef* magazine, women who deliver religious sermons in Egypt are pronounced inept. The thousands of others who attend their lectures are written out as feeble-minded individuals who lack proper discernment. Yet, in the Cairene suburb in which I conducted my study, hundreds of women from various socioeconomic levels of society attend religious lessons linked to some form of activism designed to help those in need. Each of them takes along with her a hope, and leaves with a promise—that of a better self and of a happier future in this life or the next. This chapter attempts to describe the impact of these activities not only on women's lives, but through their lives, on Egyptian society.

As a starting place, I shall describe the escalating events surrounding the rise in popularity of the *da'iyah* Sherine Fathi in a mosque in a Cairo suburb. Without doubt the most popular Islamic *da'iyah* in Cairo today, Fathi is in a league of her own. The tension that arose between Sherine

[1] The term "*abeth*" is used which denotes as well an element of "playing around".
[2] Mohamed Abdel-Sami' Gad, "Today's Fad That All Who 'Stand and Stamp' (their feet) Discuss Politics, Religion and Sex," in *Rose El Youssef*, #3751, 2000, p. 29.

Fathi, the religious scripturalists and the state created a triangle that acted as a model—on a wider social scale—of the dynamics that characterize Islamic women's activism and generally impact these women's empowerment. I will attempt to interpret these events through the converging perspectives that are employed to understand Islamic activism for women. Central to these paradigms are the notions of agency and empowerment with which current anthropological literature is highly engaged.

Sherine Fathi: A Star Preacher

Born almost forty years ago in the Cairo suburb of Misr al-Gadida, with her father an assistant to the Minister of Defense and her mother a homemaker to her family, Sherine Fathi was raised in an upper-middle-class household. Busy bringing up her children in the 1980s, Fathi nevertheless pursued the study of the Qur'an and Islamic history. She managed to help thirty women learn the Qur'an by heart. From there, she began to explore the possibility of taking courses at al-Azhar. By then, al-Azhar had closed its doors to any non-Azhar matriculated students, so she decided to apply to the Institute of Preachment. Thus, her career as a preacher began. Fathi now preaches at the mosque of al-Nasr.

I entered al-Nasr Mosque to find a large hall packed with women, whom I guessed numbered at least 300. The majority were wearing head veils, as this was inside a mosque and even women who are unveiled should don a scarf. Most of the women were from the middle to upper middle class and middle-aged, or thirty to fifty years old. At least ten per cent were teenagers. A few of the women were dressed in jeans and training suits, while the majority wore formal dress or an Arabian-style *'abaya* (cloak).

Paying close attention to what Fathi was saying, I first noticed how the set-up mirrored that of the Friday sermon for men, with the imam sitting on a low chair or *maq'ad* and the congregation at his feet. Everyone's eyes were riveted to the *da'iyah*, whose veil and dress were in pure white. Using the microphone she said,

> *Love for God. Plant the seed of this love in your children's hearts... Religion is not about scary tactics or punishment, it is about feeling. If you really feel comfortable with yourself and your*

conscience then go ahead. Address your conscience. The voice of your conscience is that of God. We are all born with it.

Fathi's appeal was irresistible. She discussed one issue after another; from God's forgiveness to today's child rearing patterns, the North Coast summer vacation and prayer, the neighbor's new Mercedes. She stressed a central theme that love and tolerance should be at the core of all daily proceedings.

These sermons were a central part of many women's lives. Women come to attend her sermons from every part of Cairo. Her popularity drew great attention to the issue of women as preachers in Egyptian society, a phenomenon not witnessed at this rate before. As her audience grew in number, Fathi grew in fame, thus forcing an examination of this issue of women preachers as part of wider social and political structures in society. Fathi was investigated and questioned by state security because the huge numbers of women who attended her sermons created traffic blocks right in front of the President's home, which was deemed threatening to the area's security. Moreover, gender issues were implicated in the ensuing tension as male *'ulama* opposed Fathi's access to the religious forum on the grounds that she was a woman. This they did by attacking her credentials and, as the above quote shows, by evoking the notion of the proper place of the Muslim woman in society. This place that is not the pulpit, according to Gad, but the home. The *'ulama's* view of women and their role in society maintain that men and women have different roles in society. They base their rationale on biological determinism.

Preaching in Egypt: A Social Phenomenon?

Despite measures of state repression of Islam's growing public role in Egypt and attempts to marginalize its political expression, its cultural success has been significant in the proliferation of voluntary Islamic organizations among the various social classes. While the relationship between Islamist movements and the phenomenon of women's religious study groups has yet to be determined, the growing popularity of preachers among the upper and upper middle classes, and among women in particular, has nevertheless raised the alarmed concern of al-Azhar University and the state through the media.

Media in Egypt is controlled by the government and accordingly reflects the states's criticism of the growing popularity of preachers and their religious sessions, which cater to thousands of men and women, because they are perceived as ground gained by Islamists in their quest for the political control of the country. "Maspero," a program that airs on national Egyptian television every Monday evening, conducted a series of interviews with various people who attended these group sessions. Without exception, each presented a sinister picture of preachers and their harmful effects on teenagers and women. The interviewer did not present the opinions of those who found these sessions beneficial; instead she concentrated on providing viewers with an explicit warning of the potential dangers of submitting to these "new preachers."

Although the popular press offers a wider range of expression, the more widely circulated magazines and newspapers tend to be conservative, particularly in their views on the relationship between religious practice and the state. A public campaign against freelance preachers is led by *Rose El Youssef* magazine, whose writers object to what, in their opinion, is the blatant political agenda of these preachers. Through a special volume dedicated to this issue, an editorial sums up the magazine's concerns: "Preachers depict society as degenerating and succumbing to delinquent as well as atheist forces." Preachers are inept and bent on material gain. They are seen as capitalizing on the ignorance of the viewers, mostly women, who, the magazine articles go on to say, often fall prey to the preachers' seeming tolerance and often end up in a veil, and are eventually led into Muslim fundamentalist groups.[3] Women, especially, are viewed by secular writer Soheir Gouda as being " ...a fertile land for any ideas addressed to them, as they possess no immune system that can repel or distinguish among random ideas." Another article states that the public is "blind" and "empty" and that upper-class women attend these sessions due to their religious ignorance, curiosity, and boredom and because they find these religious study groups fashionable. It calls upon the "proper authorities" to take action against these religious groups in order to avoid any more damage to society.[4]

[3] *Rose El Youssef*, #3750, 2000, pp. 24-29.
[4] Soheir Gouda, "Preaching According to 'Yasmine al-Khayyam'", *Rose El Youssef*, #3750, 2000, pp. 25-27.

"The proper authorities" are presented as none other than al-Azhar and the Egyptian government. Dr. Mohamed Sayyid Tantawi, Sheikh al-Azhar and the highest religious authority in Egypt, comments to Iqbal al-Seba'i of *Rose El Youssef*,

> It is not right for the *mufti*[5] to express an opinion about a religious matter unless he properly understands the issue and uses the proper documentation for this from the *shari'a*. We advise Muslims who seek answers from those who are unqualified [to stop doing so] and to ask the specialists instead, in whom the criteria of *iftaa*[6] apply.

Tantawi then quotes from the Qur'an verses that support this view, and follows by addressing himself to preachers and asking them to fear God in what they say because delivering a *fatwa* is a great responsibility. [7]

On the Islamic religious front, *'ulama* administrators and officials are divided on the issue of women being preachers. Al-Azhar *'ulama* state that, "Women should not be teachers of religion."[8] Similarly, Dr. Abdel-Rachid Salem, the author of 21 books on Islam as well as Under Secretary of State responsible for the *da'wa*, maintains that women can never under any circumstances stand on a *minbar* (pulpit) and deliver the Mosque sermon. They are neither legally nor officially authorized to do so. The phenomenon described in the media today is different. In Dr. Salem's view, these study groups are no more than Islamic culture sessions, which are closely guarded and monitored by the government's *da'wa* sector.[9] On the other hand Muhamed Bisar, Vice-Dean of al-Azhar in 1975, makes the following statement,

> What our society now lacks is the preparation of a generation of girls and women to work in the field of preaching religion to the society of women in Egypt and the Islamic world. Women are more able to establish a

[5] A "*mufti*" provides council as well articulates the Islamic standpoint on issues in society.
[6] A religious decree, usually proclaimed by the *mufti*.
[7] *Rose El Youssef*, #3750, 2000, pp. 24-29.
[8] A. Chris Eccel, *Egypt, Islam, and Social Change: Al-Azhar in Conflict and Accommodation* (Berlin: K. Schwarz, 1984) p. 388. Also see opening quote.
[9] Soheir El Imam, " Dr. Abdel-Rachid Abdel Aziz Salem Assures: Women Cannot be Preachers," *Le Progres Egyptien*, Jan. 1996.

common understanding with members of their own sex, and more able to convince them.[10]

The ambivalence in the points of view of Islamic scripturalists today and in the recent past indicates that the issue of women as preachers is not a simple one that can be understood in general terms. The fluctuating opinions vary according to their position in time, with views becoming more rigid and inflexible the more recent they are. Religious authorities a quarter of a century ago called for women Islamic scholars, but now that they have arrived they have turned out to be frightening in their challenges, both latent and real, to traditional practices of religious education. The sweeping phenomenon of women preachers and the growing number in religious study groups in urban Egypt today has led to the sanctions delivered by al-Azhar officials.

In an interview with the women's magazine *Nisf al-Donya*, Sherine Fathi revealed a new development on the issue of preachers and internal security in Egypt.[11] Internal security has maintained a tight control over the public activities of Islamists in the past years, fearing a resurgence of fundamentalist violence. As preachers become more popular and are treated like celebrities, their power and prestige is becoming perceived as a threat to security. As she was preparing to deliver one of her religious sermons, Sherine Fathi was refused access to the mosque that lies across the street from the Presidential residence. Cheered on by an outraged audience, Fathi took matters into her own hands and met the Minister of Religious Endowments, Hamdi Zaqzouk, and also paid a visit to Internal Security. Whether owing to her family background (her father having been a prominent military figure) or to pressure from her influential audience, Fathi was granted permission to preach from the Internal Security Bureau as well as the approval of the Ministry of Religious Endowments.

Islamic Women in the Middle East

Much has been written about Islamic women in the Middle East, as this thesis has presented in its first chapter. Many social scientists attest to the

[10] Eccel, p. 388 quoting a*l-Ahram*, Aug. 22, 1975. p. 11.
[11] Abdel Aal, p. 101.

97

fact that women in the Middle East and in Egypt have been able to unsettle the social discourses of male domination to allow more freedom for women to enter the public sphere (as opposed to the private sphere of the home) and to assume prominent positions. This has, in turn, enabled a reevaluation of women's role and status in society at large.[12] Islamic women activists, as we have seen, have been the "oppressed" as well the "feminist subject" of anthropological studies. The circumstances that surround the case of Sherine Fathi can be viewed through a variety of lenses.

As the focus in contemporary anthropological scholarship seems to center on the notions of agency and empowerment, a consideration of Fathi's case can at first glance lead an investigation along those lines. As Fathi is a woman and an Islamic *da'iyah*, she represents the perfect example of a marginalized woman in society who, because of her sense of agency, engages in an activism to resist traditional male authority and a gender discriminating state. As she struggles for self-expression, Fathi can be viewed as a feminist activist who seeks freedom from undermining traditions. According to this rationale, Fathi is actualizing the notion of "authentic feminism."

> Clinging to their heritage is women's way of imposing a semblance of order on an otherwise confusing world and their means of restoring self-worth and lessening alienation.... They are taking out of it education and professional careers, the elements consistent with their heritage and Islamic traditions, and they are leaving out all the rest.[13]

Islamic women activists like Fathi are similarly represented in terms that Western liberal feminism has normalized in discussions on women's emancipation and struggle for gender equality. Views that follow this paradigm will represent Fathi as a feminist who resists in order to achieve her empowerment based on her freedom in choosing her career, thus creating a framework that surrounds Islamic women's activism today in an aura of feminism, agency and empowerment. If one follows such reasoning, one issue will remain unresolved, and that is: can Islam act as an "authentic" ideology for empowerment? Studies attributing agency and empowerment

[12] Elizabeth Fernea, "The Challenges for Middle Eastern Women in the 21st Century," *Middle East Journal,* vol. 54:2, spring 2000, pp. 185-193.
[13] Abdel Kader, p. 137.

as goals for Islamic women will struggle with the challenge of creating compatible relations between what they see as a brand of feminism based on patriarchal systems. Here the argument focuses on proving that Islam is not patriarchal, but that it is the patriarchal interpretations that have disadvantaged women. Consequently Islamic women, according to this view, are gender activists, Islamic feminists, and women who possess agency.

However, Asad's discussion of agency as a preoccupation of modern Western thought and not as a singular lens from which to view human action prompted an examination of the various practices that women undertake to create an improved self. Religious ritual and activism enforce intense measures of discipline on these women, imbuing them with self-perfection and projecting this notion on how others see them in society. In this study I have tried to escape the conceptions that enforce a unified categorization of all Islamic women who seek to create for themselves a religious activism as a way to reach closeness with God. My perspective is one of those urged upon anthropologists by Michael Herzfeld to stake out "...the 'militant middle ground'—a space that at once is strongly resistant to closure and that is truly grounded in an open-ended appreciation of the empirical."[14] Women like Sherine Fathi are perpetuating a notion of religiosity that aims at self-perfection and actively promotes it for others. To her, feminism and emancipation from gender discrimination are irrelevant paradigms. What women like her are attempting is a far removed project that cannot be viewed except from the perspectives they represent. The data I collected from my interactions with Islamic women activists highlighted the centrality of religion in their project to enhance their inner selves in pursuance of closeness with their divine creator. This is not to say that empowerment is not implicated in these practices; on the contrary empowerment is clearly articulated, as I have shown in the accounts of Maha and Salma. Resistance is exemplified as in the dispute over space, and demonstrates that these concepts do exist among the women. However, their meanings to the women differ from how feminism understands them. To Islamic women activists, empowerment is not a goal but a tool or method to reach a Muslim ideal. The women of al-Fath were not resisting their male

[14] Michael Herzfeld, *Anthropology: Theoretical Practice in Culture and Society* (Malden: Blackwell Press, 2001) p. x.

neighbors because they wanted to *assert* their religious space: they had already constructed that space through their religious practices. What they were doing was *preserving* that space in order to continue with their Islamic activism. Similarly, Sherine Fathi was resisting the state and the *'ulama* not because her goal was informed by a feminist desire to extend women's public power, but because she sought proximity to God.

Islamic women activists claim a public space in the religious revival, which finds expression in widespread popular movements sweeping across class and socioeconomic levels in contemporary Egypt. In Cairo, where this study is set, Islamic women's activism affects women who voluntarily bequeath themselves to its disciplinary demands and expectations of personal religiosity. I have argued that women submit themselves to religious *'ibadat* and *mo'amalat* as powers of discipline that are charged with the production of the ideal Muslim woman in contemporary Islamic discourse towards which social ideals are increasingly oriented. Thus, Islamic women undertake what Foucault has described as the "technologies of the self," as means by which human beings transform themselves to attain an improved state of being. In mastering these technologies of the self, Islamic women reach higher levels of religious piety, and as a consequence acquire a sense of empowerment in social, psychological, and political terms without repulsing cultural norms as the research has shown. Islamic women are empowered because they exercise "the ability to take one's place in whatever discourse is essential to action and the right to have one's part matter, whether that is in state politics, family life, community action, or the economy."[15]

By asserting their claims over the public religious space as preachers, teachers, activists, and religious scholars, Islamic women have challenged male domination over these spheres. They hold positions of leadership and power, which in themselves redefine women's roles to encompass more productive and central involvement in society. Islamic women influence the course of male Islamic movements to consider women-centered goals and activism that they make impossible to ignore. They change the conditions that undermine women such as illiteracy, lack of health care, and poverty. As they acquire skills of management, preaching, and leadership, Islamic

[15] Carolyn G. Heilburn as quoted in Botman, p. 115.

women activists learn how to influence and affect decision-making within their spheres.

Islamic women activists recounted that they were empowered in ways that provide them with an inner satisfaction derived from helping others and inducing social change. They commented on their self-confidence and sense of achievement derived from reaching higher levels of religious mastery and knowledge. As they honed their inner selves, they emotionally benefited from the feelings of love, solidarity, and the sisterly relationships they shared with each other. Their activism provided them with an "anchor" from the daily and mundane and imbued them with direction and a sense of identity that did not conflict with the patterns of their social fabric. Islamic knowledge provided guidance and help in their lives as they derived support from sharing their knowledge while constantly learning and improving themselves.

Muslim countries of the Middle East have a distinct gender disparity in literacy and education, as well as low rates of female labor force participation. Islamic doctrine cannot be held as the major determinant of women's status in these societies. Moreover, Muslim women have argued that Islam is not unjust to women; rather, it is the male-dominated religious institutions that have presented an inherently negative interpretation of women's place in Islam. In Egypt today, Islamic activism and scholarship have begun a process of "reevaluation." It is my contention that the dynamics of the women's Islamic movement draws attention to the need to consider new paradigms of empowerment for women. Women who are actively involved in movements to improve conditions for women and children in their societies but who do not openly oppose existing gender relations are not perceived by most scholars as being empowered because they are seen as subordinated by men. The religious ideology to which Islamic women activists subscribe today is informed by patriarchal ideologies, which assert male authority over women and emphasize the latter's domestic roles. However, these women uphold the principles of patriarchy that Islam sought to balance in order to create a fair and just society and to restore to women an honored position in society. According to Islamic scholar Heba Raouf Ezzat, patriarchy as practiced today has veered from its original path. She finds that women are unjustly treated in a

system that supports male domination over women, but does not uphold men's Islamic obligations towards women:

"So what is it you want?" she asked me. "Are you happy with the secular social system that we have in Egypt today? Do you think women are better off now?" "No," I replied, "I do not believe that is so." Then Heba asked me if I thought marriage was really a great idea and I replied that whereas it is not ideal, it is a necessary institution.

And so is patriarchy. Patriarchal systems are necessary in our societies. They uphold the family and take care of women. But what we have today is not patriarchy, nor is it anything. It is a mixed salad of ideas we took from the West and the East. Women are neither honored by patriarchal norms nor are they protected by secular regimes. They are in the worst possible situation. The answer is to uphold the values and obligations of Islamic patriarchy. This is where an old woman will find respect and honor.

Thus Islamic women seek to obligate men to their patriarchal duties towards women by holding *themselves* to the highest Muslim standard of the ideal woman. As Islamic women activists strive to attain religious perfection, they lay their claim to public space, to knowledge and to prolific religious practice. In their various endeavors they exemplify Foucault's notion of "productive power," which describes how power is generated through the application of the technologies of the self. This study has tried to demonstrate that not all bodily disciplines are necessarily coercive and damaging to the self, and that disciplinary processes provide a wide spectrum of practices whose impact range from the invasive to the regulatory. Institutional and everyday life pedagogies acting on Islamic women's subjectivity suggest an enhancement in social, psychological and political domains. Islamic women empower themselves by mastering the disciplinary practices imposed by patriarchal ideologies. This is reflected in Islamic women's views about praying and their perception on veiling and domestic duties. It is also illustrated in how women voluntarily join Islamic organizations and the ways in which many of them give up time, effort, and dedication to commit themselves to the rigors of the Islamic pedagogical tradition.

Studies of Western women who undertake similar social experiences by which they subordinate themselves to the technologies of femininity, such as beauty and weight loss programs, indicate that these women stand to benefit socially, economically, and politically. Yet this empowerment is deceptive. Sandra Bartky has emphasized the heavy burdens carried by women who are caught in "no win" situations designed by patriarchal modernities to keep women in positions of subordination. Bartky evokes the anguish of women who dedicate time, money, and effort into structuring their looks in ways that correspond to ideals of femininity in society. As they pursue this ideal, they are ridiculed for being superficial and self-centered. The author describes the modern notions of domination over women's bodies to have transposed the traditional norms of female subordination by the husband and by the religious establishment. Power over women today, according to Bartky, is anonymous and is manifested in the feeling of surveillance women have over their bodies lest they mark their carefully cultivated exterior image.[16]

While my goal is not to compare religious practice with practices of personal cosmetics, the implications are too poignant to ignore, especially with regards to women and patriarchy. I aim to show that surrender may not always disempower, nor does resistance necessarily amount to empowerment. Earlier I explored views over the notions of the self in modern liberal societies as opposed to those prevailing in the Middle Eastern region. The emphasis on freedom, autonomy, and independence in liberal societies contradicts the notion of a self that thrives on connective relationships. Relations of power precede the individual and create the subject. In Western societies, which are predicated upon notions of freedom, capitalism, and democracy, women are still subordinated by patriarchal ideals of femininity that idealize youth, beauty, and the perfect body. In a Western patriarchal culture, which valorizes transient and physical aesthetics of femininity, women who refuse to submit themselves to bodily discipline in a world dominated by men incur the refusal of male patronage. Bartky surmises that,

> ...feminism, especially a genuinely radical feminism that questions the patriarchal construction of the female body, threatens women with a

[16] Bartky, p. 77.

certain de-skilling, something people normally resist: beyond this it calls into question that aspect of personal identity that is tied to the development of a sense of competence.[17]

In other words, many women in Western societies are not feminist because they choose to preserve their identity as sexually desirable, which structures their universe and allows them access to the resources with which such a structure rewards them. Empowerment for these women therefore centers on capitalizing on femininity as it is idealized in society. Equal rights for women based on the abolishment of gender differences can, therefore, inadvertently hurt these women's interests. Despite this kind of loss, however, the majority of women have enjoyed the benefits the feminist movement has allowed women to have: independence, freedom, and autonomy as public citizens.[18]

In Middle Eastern societies, Islamic women activists face subordination in society as a result of a complexity of factors, foremost among which are patriarchal systems favoring men over women. In Cairo, hundreds of Muslim women have rallied around Islamic movements that appear to be formed by diverse trends, but that organize on central themes. These women adopt Islamic principles that have been employed historically by men to further their domination over women and to bolster their power over the family, society and politics. The discourses that inform Islamic women activists are influenced by these patriarchal notions emphasizing women's domestic duties, obedience to the husband, and restricted roles. In turn, women's discourses call for other women to divest themselves of exploitative Western practices, which commodify women, rob them of their God given rights and their "femininity." Sayyid Qutb, an Islamist leader, noted that increased materialism led to *jahilia* (a state of ignorance, i.e. not civilized) by which he describes Western societies:

> These societies that give ascendance to physical desires and materialistic morals cannot be considered civilized, no matter how much progress they make in industry or science.[19]

[17] Ibid, p. 77.
[18] More contemporary dilemmas over what whether the freedoms enjoyed by women have resulted in "happiness". See, Carla Power, "Women of the New Century," Special Report, *Newsweek*, vol. CXXXVII, #02, Jan. 8, 2001.
[19] Sayyid Qutb as quoted in Karam, p. 178.

Instead, Islamic women activists posit an alternative for women in their society to acquire skills of Islamic teachings, by virtue of which they can elevate their senses over the materialism of the body as means of contributing to the development of a civilization that emphasizes human character values rather than materialism.

Islamic women do not view themselves as free and autonomous creations who search for independence from unjust male control and access to the material goods men have accrued to themselves. Instead, they see themselves as deeply connected to each other, to the husband and the family and ultimately to God in relations of obligation and love. Their empowerment is sought through these connective relations rather than despite them. The social system in Egypt, which is based on patriarchy, creates structures that dominate women and may hold them more responsible than men for their obligations, but have nevertheless traditionally obligated men to women. However, these obligations have been undermined, first by the state and later by modernizing processes, which have reformulated the family from an extended kinship system to small independent units. In countries such as Egypt these shifts have served to alienate women and placed them at the mercy of governmental policies, which as we have seen were not adequate in providing economic sustenance or social support.[20] Poverty has been feminized, and between 6 and 15 per cent of Egyptian families live in women-run households.[21] While patriarchal ideologies that favor men at the expense of women still thrive, traditional values that have obligated men to women have receded and conditions have left women more defenseless than they had ever been.

Thus Islamic women activists see some merit in a patriarchal system that, rather than valuing physical and superficial attributes of infantalized femininity, values instead wisdom and age, and honors elderly women as well as providing for them. Yet patriarchal ideals untempered by notions of Islamic justice and ethics have proven capable of being harmful to women

[20] Haugaard Kirsten Bach, "The Visions of a Better Life: New Patterns of Consumption and Changed Social Relations" in Nicholas S. Hopkins and Kirsten Bach, eds., *Directions of Change in Rural Egypt* (Cairo: American University in Cairo Press, 1998) pp. 184-200.
[21] Heba Handoussa, *Employment and Structural Adjustment: Egypt in the 1990s* (Cairo: American University in Cairo Press, 1994).

and of perpetuating misogynist practices against them. Islam, among other movements, attempted to bring justice to gender relations in the Arabian Peninsula; but this mission was never fully realized. Instead of Islam controlling and ordering patriarchy, it is Islam that has come to be controlled and manipulated by male-centered interpretations that serve men's interests and favor men's rights over women's. To the broad spectrum of its population, Islamism in today's Egypt poses as the only alternative that carries a visionary ideology. The emergence of Islamic women activists at the head of a sweeping movement in society has signaled their participation in shaping responses to hegemonic discourses. As they rely on the orthodox body of work of male religious thinkers Islamic women employ discourses they have not produced, and with their newly formed activism lack the knowledge and confidence that otherwise could drive them to formulate their own. The growth in momentum of Islamic women's scholarly contributions perhaps holds a promise for the establishment of a full-fledged Islamic women's movement that may head in the direction of a more woman-centered articulation of Islam. I believe that Islamic texts have demonstrated, in other contexts, their propensity for application to women's interests, as for example in Iran. As yet, a patriarchal imbalance remains at the heart of political and social systems in Egypt, which only a popular movement as the Islamic women's movement with an articulated women's ideology—feminist or not—can redress.

REFERENCES

Abdel Kader, Soha. 1987. *Egyptian Women in a Changing Society*. U.S.A: Lynne Rienner Publishers.

Abdel Sami' Gad, Mohamed. 2000. "Today's Fad that all who 'Stand and Stamp' (their feet) Discuss Politics, Religion and Sex," *Rose El Youssef*, #3751, p. .29.

Abu-Lughod, Lila. 1998. " The Marriage of Feminism and Islamism: Selective Repudiation as A Dynamics of Post-colonial Cultural Politics" in Lila Abu-Lughod, ed., *Remaking Women*. Cairo: American University in Cairo Press.

Abou-Bakr, Omaima. 2000. "A Muslim Woman's Reflections on Gender," in *International Forum for Islamic Dialogue*: www.islam21.org/main/women.htm.

Afshar, Haleh. 1996. "Islam and Feminism: An Analysis of Political Strategies" in Mai Yamani, ed.,. *Feminism and Islam: Legal and Literary Perspectives*. London: Ithaca Press. Pp. 197-215.

Ahmed, Leila. 1993. *Women and Gender in Islam: Historical Roots of a Modern Debate*. Cairo: American University in Cairo Press.

Al-Ahram Center for Political and Strategic Studies. 1995. *The State of Religion in Egypt Report*. Cairo: Al-Ahram Foundation.

Al-Ali, Nadje Sadig. 1997. "Feminism and Contemporary Debates in Egypt" in Dawn Chatty and Annika Rabo, eds., *Organizing Women: Formal and Informal Women's Group In the Middle East*. Oxford: Oxford International Publications.

Altorki, Soraya. 1986. *Women In Saudi Arabia: Ideology and Behavior Among the Elite*. New York: Columbia University Press.

----------------. 2000. "The Concept and Practice of Citizenship in Saudi Arabia" in Suad Joseph ed., *Gender and Citizenship in the Middle East*. Syracuse: Syracuse University Press.

Amin, Galal. 1997. *Matha Hadath Lil Masryyin?* (What Has Happened to the Egyptians?). Cairo: Dar El Hilal.

Ask, Karin and Marit Tjomsland. 1998 *Women and Islamization: Contemporary Dimensions of Discourse on Gender Relations*. Oxford: Berg.

Bach, Haugaard Kirsten. 1998. "The Visions of a Better Life: New Patterns of Consumption and Changed Social Relations" in Nicholas S. Hopkins and Kirsten Bach, eds., *Directions of Change in Rural Egypt.* Cairo: American University in Cairo Press, pp. 184-200.

Badran, Margot. 1991. "Competing Agenda: Feminists, Islam and the State in 19th and 20th century Egypt" in Deniz Kandiyoti, ed., *Women, Islam and the State*. Hampshire: Macmillan Press Limited, pp.201- 237.

---------------. 1996. *Feminists, Islam, and Nation: Gender and the Making of Modern Egypt*. Cairo: American University in Cairo Press.

Bailey, M.E. 1993. "Foucauldian Feminism: Contesting Bodies, Sexuality and Identity." in Caroline Ramazanoglu, ed., *Up Against Foucault*. New York: Routledge.

Bartky, Sandra Lee. 1990. *Feminism and Domination: Studies in the Phenomenology of Oppression*. New York: Routledge.

Bassyouny, Iman Farid. 1997. *"'Just a Gaze': Female Clientele of Diet Clinics in Cairo," Cairo Papers in Social Science*, vol. 20, monograph 4, winter.

Botman, Selma. 1999. *Engendering Citizenship in Egypt: The History and Society of The Modern Middle East*. New York: Columbia University Press.

Butler, Judith. 1997. *The Psychic Life of Power: Theories in Subjection*. California: Stanford University Press.

Cole, Juan Ricardo. 1981. "Feminism, Class, and Islam in Turn of the Century Egypt," *International Journal of Middle East Studies*, vol. 13, pp. 387-407.

Cooke, Miriam. 2001. *Women Claim Islam: Creating Islamic Feminism Through Literature*. New York: Routledge.

Diamond, Irene and Lee Quinby, eds. 1988. *Feminism and Foucault: Reflections on Resistance*. Boston: Northwestern University Press.

Duval, Soroya. 1998. "New Veils and New Voices: Islamist Women's Groups in Egypt," in Karin Ask and Marit Tjomsland, eds., *Women and Islamization: Contemporary Dimensions of Discourse on Gender Relations*. Oxford: Berg, pp. 45-73.

Eccel, A. Chris. 1984. *Egypt Islam and Social Change: Al-Azhar in Conflict and Accommodation*. Berlin: K. Schwarz.

Esposito, John. 1998. "Introduction" in Yvonne Yazbeck Haddad and John L. Esposito, eds., *Islam, Gender and Social Change*. New York: Oxford University Press.

Ezzat, Heba Raouf. 1992. *Women and Political Work: An Islamist Perspective*. Washington: International Institute of Islamic Thought.

---------------. 1999. "Women and the Interpretation of Islamic Resources," International Forum for Islamic Dialogue. www.islam21.org/main/women.html.

Fernea, Elizabeth. 2000. "The Challenges for Middle Eastern Women in the 21st. Century," *Middle East Journal*, vol. 54:2, spring, pp. 185-193.

Flax, Jane. 1987. "Postmodernism and Gender Relations in Feminist Theory," *Signs*, vol. 12 :4.

Fleischmann, Ellen. 1999. "The Other Awakening: The Emergence of Women's Movements in the Modern Middle East, 1900-1940" in M. Meriwether and Judith Tucker, eds., *A Social History of Women and Gender in the Modern Middle East*. Boulder: Westview Press, pp. 89-123.

Foucault, Michel. 1988. "Technologies of the Self" in Martin Luther, Hugh Gutman and Patrick H. Hutton, eds., *Technologies of the Self: A Seminar with Michel Foucault*. Amherst: University of Massachusetts Press, pp. 16-50.

--------------. 1979. *Discipline and Punish: The Birth of the Prison*. New York: Vintage.

Gaffney, Patrick. 1994. *The Prophet's Pulpit: Islamic Preaching in Contemporary Egypt*. Berkeley: California University Press.

Ghadbain, Najib. 1997. *Democratization and the Islamist Challenge in the Arab World*. Boulder: Westview Press.

Al-Ghazali, Zeinab. 1982. *Ayyam Min Hayaty* (Days from My Life). Cairo: Dar al-Shuruq.

Gouda, Soheir. 2000. "Preaching According to 'Yasmine Al Khayyam,'" *Rose El Youssef*, #3750, pp. 25-27.

Graue, M.E. 1997. "Definition of Ethnography" in Carl A. Grant and G. Ladson Billings, eds., *Dictionary of Multicultural Education*. Phoenix: Oryx Press.

Guenena, Nemat. 1986. *"The 'Jihad': An Islamic Alternative in Egypt," Cairo Papers in Social Science*, vol. 9, monograph 2, summer.

Haddad, Yvonne Yazbeck and John L. Esposito, eds. 1998. *Islam, Gender, and Social Change*. New York: Oxford University Press.

Haddad, Yvonne Yazbeck, and Jane I. Smith. 1996. "Women in Islam: 'The Mother of All Battles'" in Suha Sabbagh, ed., *Arab Women: Between Defiance and Restraint*. New York: Olive Branch Press, pp.137-150.

Handoussa, Heba. 1994. *Employment and Structural Adjustment: Egypt in the 1990s*. Cairo: American University in Cairo Press.

Hatem, Mervat. 1986. "The Enduring Alliance of Nationalism and Patriarchy in Muslim Personal Status Law: The Case of Modern Egypt," *Feminist Issues*, 6(1):19-43.

----------------. 1992. "Economic and Political Liberation in Egypt and the Demise of State Feminism," *International Journal of Middle East Studies*, vol. 24, pp. 231-51.

Herzfeld, Michael. 2001. *Anthropology: Theoretical Practice in Culture and Society*. Malden: Blackwell Press.

Hijab, Nadia. 1998. "Islam, Social Change and the Reality of Arab Women's Lives" in Yvonne Yazbeck Haddad and John L. Esposito, eds., *Islam, Gender, and Social Change*. New York: Oxford University Press, pp. 46-47.

Hoodfar, Homa. 2000. "Iranian Women at the Intersection of Citizenship and the Family Code: The Perils of 'Islamic Criteria'" in Suad Joseph, ed., *Gender and Citizenship in the Middle East*. Syracuse: Syracuse University Press, pp. 287-313.

El Imam, Soheir. 1996. "Dr. Abdel Rachid Abdel Aziz Salem Assures: Women Cannot Be Preachers," *Le Progres Egyptien*, January.

Islamic Center for Study and Research. 1994. *The Muslim Woman in the Muslim Society*. Cairo.

Jeffery, Patricia and Amrita Basu, eds. 1998. *Appropriating Gender: Women's Activism and Politicized Religion in South Asia*. New York: Routledge Press.

Joseph, Suad. 1994. "Brother/Sister Relationships: Connectivity, Love, and Power in the Reproduction of Patriarchy in Lebanon," *American Ethnologist*, vol. 21:1.

---------------, ed. 2000. *Gender and Citizenship in the Middle East*. Syracuse: Syracuse University Press.

Kamalkhani, Zahra. 1998. " Reconstruction of Islamic Knowledge and Knowing" in Karin Ask and Marit Tjomsland, eds., *Women and Islamization: Contemporary Dimensions of Discourse on Gender Relations*. Oxford: Berg, pp. 175-193.

Kandiyoti, Deniz, ed. 1991. *Women, Islam and the State*. Hampshire: Macmillan Press Limited.

---------------. 1996. "Islam and Feminism: A Misplaced Polarity," *Women Against Fundemamentalisms*, #8.

Karam, Azza. 1998. *Women, Islamisms and the State*. New York: St. Martin's Press.

Kienle, Eberhard. 1998. "More Than a Response to Islamism: The Political Deliberalization of Egypt in the 1990s," *Middle East Journal*, 52:2, spring.

Lazrag, Marnia. 1994. *The Eloquence of Silence: Algerian Women in Question*. New York: Routledge.

Luke, Carmen, ed. 1996. *Feminisms and Pedagogies of Everyday Life*. Albany: State University of New York Press.

Mahmood, Saba. 1996. "Interview with Talal Asad: Modern Power and the Reconfiguration of Religious Traditions," *Stanford Electronic Humanities Review*, 5:1, February.

---------------. 1998. *Women's Piety and Embodied Discipline: The Islamic Resurgence in Contemporary Egypt*. U.S.A: UMI.

Mernissi, Fatima. 1996. "Muslim Women and Fundamentalism" in Suha Sabbagh, ed., *Arab Women: Between Defiance and Restraint*. New York: Olive Branch Press.

Metcalf, Barbara D. 1998. "Women and Men in a Contemporary Pietist Movement: The Case Of Tablighi Jama'at" in Patricia Jeffery and Amrita Basu (1998). *Appropriating Gender: Women's Activism and Politicized Religion in South Asia*. New York: Routledge Press, pp. 107-108.

Moghadam, Valentine, ed. 1994. *Identity Politics and Women*. Boulder: Westview Press.

---------------. 1993. *Modernizing Women: Gender and Social Change in the Middle East*. Cairo: American University in Cairo Press.

Moghissi, Haideh. 1999. *Feminism and Islamic Fundamentalism: The Limits of Postmodern Analysis*. London: Zed Books.

Najmabadi, Afsaneh. 1998. "Feminism in an Islamic Republic: Years of Hardship, Years of Growth" in Yvonne Yazbeck and John L. Esposito, eds., *Islam, Gender, and Social Change*. New York: Oxford University Press, pp. 59-84.

Nelson, Cynthia. 1986. "The Voices of Doriya Shafik: Feminist Consciousness in Egypt From 1940- 1960," *Feminist Issues*, 6:29, fall, pp. 15-31.

Oxaal, Zoë, and Sally Baden. 1997. "Gender and Empowerment: Definitions. Approaches, and Implications for Policy (report 40)". Briefing prepared for the Swedish International Development Cooperation Agency (Sida).

Papanek, Hanna. 1994. "The Ideal Woman and the Ideal Society: Control and Autonomy in the Construction of Identity" in Valentine Moghadam, ed., *Identity Politics and Women*. Boulder: Westview Press, pp. 42-75.

Pateman, Carol. 1988. *The Sexual Contract*. Oxford: Polity Press.

Power, Carla. 2001. "Women of the New Century," Special Report, *Newsweek*, vol. CXXXVII, #02, January 8.

Rasmussen, Lene Kofoed. 1998, " Muslim Women and Intellectual(s) in 20th Century Egyptian Public Debate." Paper presented in the Fourth Nordic conference on Middle Eastern Studies, Oslo.

Salim, Layla. 1990. "Al Mar'a fi Da'wat wa Fikr Hasan al Banna: Bayn al-Madi wa al-Hadir" (Women in the Da'wa and Thought of Hasan al-Bana: Between the Past and the Present), *Liwaa al-Islam*, January, #52.

Sawicki, Jana. 1991. *Disciplining Foucault. Feminism, Power, and the Body*. New York: Routledge.

Scott, James, C. 1990. *Domination and the Arts of Resistance*. New Haven: Yale University Press.

Sullivan, Denis and Sana Abed-Kotb. 1999. *Islam in Contemporary Egypt: Civil Society vs. the State*. Boulder: Lynne Rienner Publishers.

Talhami, Hashem Ghada. 1996. *The Mobilization of Muslim Women in Egypt*. Florida: University Press of Florida.

United Nations. 1995. *Report of the Fourth World Conference on Women*. Beijing.

Wadud-Muhsin, Amina. 1992. *Quran and Woman*. Kuala Lumpur: Fajar Bakr.

Zuhur, Sherifa. 1995. "Women Can Embrace Islamic Gender Roles" in David Bender and Bruno Leone, eds., *Islam: Opposing Viewpoints*.San Diego: Greenhaven Press, pp. 89-98.

ABOUT THE AUTHOR

Sherine Hafez is a PHD candidate at University of California, Davis. This research is based on her MA Thesis at the Sociology/Anthropology Department, the American University in Cairo.

CAIRO PAPERS IN SOCIAL SCIENCE
بحوث القاهرة فى العلوم الإجتماعية

VOLUME ONE 1977-1978
1 *WOMEN, HEALTH AND DEVELOPMENT, Cynthia Nelson, ed.
2 *DEMOCRACY IN EGYPT, Ali E. Hillal Dessouki, ed.
3 MASS COMMUNICATIONS AND THE OCTOBER WAR, Olfat Hassan Agha
4 *RURAL RESETTLEMENT IN EGYPT, Helmy Tadros
5 *SAUDI ARABIAN BEDOUIN, Saad E. Ibrahim and Donald P. Cole

VOLUME TWO 1978-1979
1 *COPING WITH POVERTY IN A CAIRO COMMUNITY, Andrea B. Rugh
2 *MODERNIZATION OF LABOR IN THE ARAB GULF, Enid Hill
3 STUDIES IN EGYPTIAN POLITICAL ECONOMY, Herbert M. Thompson
4 *LAW AND SOCIAL CHANGE IN CONTEMPORARY EGYPT, Cynthia Nelson and Klaus Friedrich Koch, eds.
5 THE BRAIN DRAIN IN EGYPT, Saneya Saleh

VOLUME THREE 1979-1980
1 *PARTY AND PEASANT IN SYRIA, Raymond Hinnebusch
2 *CHILD DEVELOPMENT IN EGYPT, Nicholas V. Ciaccio
3 *LIVING WITHOUT WATER, Asaad Nadim et. al.
4 EXPORT OF EGYPTIAN SCHOOL TEACHERS, Suzanne A. Messiha
5 *POPULATION AND URBANIZATION IN MOROCCO, Saad E.Ibrahim

VOLUME FOUR 1980-1981
1 *CAIRO'S NUBIAN FAMILIES, Peter Geiser
2&3 *SYMPOSIUM ON SOCIAL RESEARCH FOR DEVELOPMENT: PROCEEDINGS, Social Research Center
4 *WOMEN AND WORK IN THE ARAB WORLD, Earl L. Sullivan and Karima Korayem

VOLUME FIVE 1982
1 GHAGAR OF SETT GUIRANHA: A STUDY OF A GYPSY COMMUNITY IN EGYPT, Nabil Sobhi Hanna
2 *DISTRIBUTION OF DISPOSAL INCOME AND THE IMPACT OF ELIMINATING FOOD SUBSIDIES IN EGYPT, Karima Korayem
3 *INCOME DISTRIBUTION AND BASIC NEEDS IN URBAN EGYPT, Amr Mohie El-Din

VOLUME SIX 1983
1 *THE POLITICAL ECONOMY OF REVOLUTIONARY IRAN, Mihssen Kadhim
2 *URBAN RESEARCH STRATEGIES IN EGYPT, Richard A. Lobban, ed.
3 *NON-ALIGNMENT IN A CHANGING WORLD, Mohammed El-Sayed Selim, ed.
4 *THE NATIONALIZATION OF ARABIC AND ISLAMIC EDUCATION IN EGYPT: DAR AL-ALUM AND AL-AZHAR, Lois A. Arioan

VOLUME SEVEN 1984
1 *SOCIAL SECURITY AND THE FAMILY IN EGYPT, Helmi Tadros
2 *BASIC NEEDS, INFLATION AND THE POOR OF EGYPT, Myrette El-Sokkary
3 *THE IMPACT OF DEVELOPMENT ASSISTANCE ON EGYPT, Earl L. Sullivan, ed.
4 *IRRIGATION AND SOCIETY IN RURAL EGYPT, Sohair Mehanna, Richard Huntington and Rachad Antonius

VOLUME EIGHT 1985
1&2 ANALYTIC INDEX OF SURVEY RESEARCH IN EGYPT, Madiha El-Safty, Monte Palmer and Mark Kennedy

VOLUME NINE 1986
1 *PHILOSOPHY, ETHICS AND VIRTUOUS RULE, Charles E. Butterworth
2 THE 'JIHAD': AN ISLAMIC ALTERNATIVE IN EGYPT, Nemat Guenena

3 *THE INSTITUTIONALIZATION OF PALESTINIAN IDENTITY IN EGYPT, Maha A. Dajani
4 *SOCIAL IDENTITY AND CLASS IN A CAIRO NEIGHBORHOOD, Nadia A. Taher

VOLUME TEN 1987
1 *AL-SANHURI AND ISLAMIC LAW, Enid Hill
2 *GONE FOR GOOD, Ralph Sell
3 *THE CHANGING IMAGE OF WOMEN IN RURAL EGYPT, Mona Abaza
4 *INFORMAL COMMUNITIES IN CAIRO: THE BASIS OF A TYPOLOGY, Linda Oldham, Haguer El Hadidi, Hussein Tamaa

VOLUME ELEVEN 1988
1 *PARTICIPATION AND COMMUNITY IN EGYPTIAN NEW LANDS: THE CASE OF SOUTH TAHRIR, Nicholas Hopkins et. al.
2 PALESTINIAN UNIVERSITIES UNDER OCCUPATION, Antony T. Sullivan
3 LEGISLATING *INFITAH* : INVESTMENT, FOREIGN TRADE AND CURRENCY LAWS, Khaled M. Fahmy
4 SOCIAL HISTORY OF AN AGRARIAN REFORM COMMUNITY IN EGYPT, Reem Saad

VOLUME TWELVE 1989
1 *CAIRO'S LEAP FORWARD: PEOPLE, HOUSEHOLDS AND DWELLING SPACE, Fredric Shorter
2 *WOMEN, WATER AND SANITATION: HOUSEHOLD WATER USE IN TWO EGYPTIAN VILLAGES, Samiha El-Katsha et. al
3 PALESTINIAN LABOR IN A DEPENDENT ECONOMY: WOMEN WORKERS IN THE WEST BANK CLOTHING INDUSTRY, Randa Siniora
4 THE OIL QUESTION IN EGYPTIAN-ISRAELI RELATIONS, 1967-1979: A STUDY IN INTERNATIONAL LAW AND RESOURCE POLITICS, Karim Wissa

VOLUME THIRTEEN 1990
1 *SQUATTER MARKETS IN CAIRO, Helmi R. Tadros, Mohamed Feteeha, Allen Hibbard
2 *THE SUB-CULTURE OF HASHISH USERS IN EGYPT: A DESCRIPTIVE ANALYTIC STUDY, Nashaat Hassan Hussein
3 *SOCIAL BACKGROUND AND BUREAUCRATIC BEHAVIOR IN EGYPT, Earl L. Sullivan, El Sayed Yassin, Ali Leila, Monte Palmer
4 *PRIVATIZATION: THE EGYPTIAN DEBATE, Mostafa Kamel El-Sayyid

VOLUME FOURTEEN 1991
1 *PERSPECTIVES ON THE GULF CRISIS, Dan Tschirgi and Bassam Tibi
2 *EXPERIENCE AND EXPRESSION: LIFE AMONG BEDOUIN WOMEN IN SOUTH SINAI, Deborah Wickering
3 IMPACT OF TEMPORARY INTERNATIONAL MIGRATION ON RURAL EGYPT, Atef Hanna Nada
4 *INFORMAL SECTOR IN EGYPT, Nicholas S. Hopkins ed.

VOLUME FIFTEEN, 1992
1 *SCENES OF SCHOOLING: INSIDE A GIRLS' SCHOOL IN CAIRO, Linda Herrera
2 URBAN REFUGEES: ETHIOPIANS AND ERITREANS IN CAIRO, Dereck Cooper
3 INVSTORS AND WORKERS IN THE WESTERN DESERT OF EGYPT: AN EXPLORATORY SURVEY, Naeim Sherbiny, Donald Cole, Nadia Makary
4 *ENVIRONMENTAL CHALLENGES IN EGYPT AND THE WORLD, Nicholas S. Hopkins, ed.

VOLUME SIXTEEN, 1993
1 *THE SOCIALIST LABOR PARTY: A CASE STUDY OF A CONTEMPORARY EGYPTIAN OPPOSITION PARTY, Hanaa Fikry Singer
2 *THE EMPOWERMENT OF WOMEN: WATER AND SANITATION INIATIVES IN RURAL EGYPT, Samiha el Katsha, Susan Watts
3 THE ECONOMICS AND POLITICS OF STRUCTURAL ADJUSTMENT IN EGYPT: THIRD ANNUAL SYMPOSIUM

4 *EXPERIMENTS IN COMMUNITY DEVELOPMENT IN A *ZABBALEEN* SETTLEMENT, Marie Assaad and Nadra Garas

VOLUME SEVENTEEN, 1994
1 DEMOCRATIZATION IN RURAL EGYPT: A STUDY OF THE VILLAGE LOCAL POPULAR COUNCIL, Hanan Hamdy Radwan
2 FARMERS AND MERCHANTS: BACKGROUND FOR STRUCTURAL ADJUSTMENT IN EGYPT, Sohair Mehanna, Nicholas S. Hopkins and Bahgat Abdelmaksoud
3 HUMAN RIGHTS: EGYPT AND THE ARAB WORLD, FOURTH ANNUAL SYMPOSIUM
4 ENVIRONMENTAL THREATS IN EGYPT: PERCEPTIONS AND ACTIONS, Salwa S. Gomaa, ed.

VOLUME EIGHTEEN, 1995
1 SOCIAL POLICY IN THE ARAB WORLD, Jacqueline Ismael & Tareq Y. Ismael
2 WORKERS, TRADE UNION AND THE STATE IN EGYPT: 1984-1989, Omar El-Shafie
3 THE DEVELOPMENT OF SOCIAL SCIENCE IN EGYPT: ECONOMICS, HISTORY AND SOCIOLOGY; FIFTH ANNUAL SYMPOSIUM
4 STRUCTURAL ADJUSTMENT, STABILIZATION POLICIES AND THE POOR IN EGYPT, Karima Korayem

VOLUME NINETEEN, 1996
1 NILOPOLITICS: A HYDROLOGICAL REGIME, 1870-1990, Mohamed Hatem el-Atawy
2 *IMAGES OF THE OTHER: EUROPE AND THE MUSLIM WORLD BEFORE 1700, David R. Blanks et al.
3 *GRASS ROOTS PARTICIPATION IN THE DEVELOPMENT OF EGYPT, Saad Eddin Ibrahim et al
4 THE ZABBALIN COMMUNITY OF MUQATTAM, Elena Volpi and Doaa Abdel Motaal

VOLUME TWENTY, 1997
1 CLASS, FAMILY AND POWER IN AN EGYPTIAN VILLAGE, Samer el-Karanshawy
2 THE MIDDLE EAST AND DEVELOPMENT IN A CHANGING WORLD, Donald Heisel, ed.
3 ARAB REGIONAL WOMEN'S STUDIES WORKSHOP, Cynthia Nelson and Soraya Altorki, eds.
4 "JUST A GAZE": FEMALE CLIENTELE OF DIET CLINICS IN CAIRO:AN ETHNOMEDICAL STUDY, Iman Farid Bassyouny

VOLUME TWENTY-ONE, 1998
1 TURKISH FOREIGN POLICY DURING THE GULF WAR OF 1990-1991, Mostafa Aydin
2 STAE AND INDUSTRIAL CAPITALISM IN EGYPT, Samer Soliman
3 TWENTY YEARS OF DEVELOPMENT IN EGYPT (1977-1997): PART I, Mark C. Kennedy
4 TWENTY YEARS OF DEVELOPMENT IN EGYPT (1977-1997): PART II, Mark C. Kennedy

VOLUME TWENTY-TWO, 1999
1 POVERTY AND POVERTY ALLEVIATION STRATEGIES IN EGYPT, Ragui Assaad and Malak Rouchdy
2 BETWEEN FIELD AND TEXT: EMERGING VOICES IN EGYPTIAN SOCIAL SCIENE, Seteney Shami and Linda Hererra, eds.
3 MASTERS OF THE TRADE: CRAFTS AND CRAFTSPEOPLE IN CAIRO, 1750-1850, Pascale Ghazaleh
4 DISCOURCES IN CONTEMPORARY EGYPT: POLITICS AND SOCIAL ISSUES, Enid Hill, ed.

VOLUME TWENTY-THREE, 2000

1. FISCAL POLICY MEASURES IN EGYPT: PUBLIC DEBT AND FOOD SUBSIDY, Gouda Abdel-Khalek and Karima Korayem
2. NEW FRONTIERS IN THE SOCIAL HISTORY OF THE MIDDLE EAST, Enid Hill, ed.
3. EGYPTIAN ENCOUNTERS, Jason Thompson, ed.
4. WOMEN'S PERCEPTION OF ENVIRONMENTAL CHANGE IN EGYPT, Eman El Ramly

VOLUME TWENTY-FOUR, 2001

1&2. THE NEW ARAB FAMILY, Nicholas S. Hopkins, ed.
3. AN INVESTIGATION OF THE PHENOMENON OF POLYGYNY IN RURAL EGYPT, Laila S. Shahd

* currently out of print

وليس كهدف فى حد ذاته. وفى اطار هذا الاستنتاج، تدعو الباحثة الى اعادة النظر فى مفهوم التمكين بمعناه الليبرالى الغربى اذا اردنا دراسة ظاهرة الناشطات الاسلاميات او ما يشابهها.

ملخص

تتعرض هذه الدراسة لظاهرة الناشطات الاسلاميات فى القاهرة بغرض التعرف على تأثير فعّاليتهم على تمكين الذات للمرأة. فى البداية، ترى الباحثة ان النموذج النسوى الليبرالى الغربى الذى عادة ما يطبق لشرح مفهوم تمكين المرأة لا يساعد على فهم الظاهرة المشار اليها فهماً كافياً وتحاول بدلاً منه الاعتماد على رؤية هؤلاء السيدات لذواتهن ولما يقمن به من أجل تقييم أثر هذه الفعّالية على تمكين المرأة.

وفى هذا الاطار، قامت الباحثة بعمل بحث ميدانى فى جمعيتين اسلاميتين تديرهما وتعمل بهما سيدات يقدمن من خلالهما خدمات اجتماعية ودينية مختلفة للمجتمع، كما حضرت بعض الدروس الدينية لسيدات الجمعيتين الى جانب اجرائها لمقابلات مطولة مع ناشطات اسلاميات أخريات. ومن اهم ما يميز الجمعيتان اختلاف مستواهما الاقتصادى والاجتماعى بحيث يمكن اعتبارهما ممثلتين للمجتمع المصرى ككل. وكانت أهم التساؤلات المطروحة تدور حول رؤية المرأة المصرية لفكرة التمكين فى الاطار الاسلامى، خاصة وان الاسلاميين عادة ماينظر اليهم بوصفهم لا يؤمنون بحرية المرأة. ثم يأتى بعد ذلك سؤال: أى نوع من التمكين يمكن للمرأة المسلمة ان تحققه من خلال نشاطاتها؟ واخيراً، كيف يمكن لفعالية هؤلاء الناشطات ان تساهم فى تمكين المرأة المسلمة فى مصر اليوم؟ وفى اثناء الاجابة على هذه التساؤلات تضع الباحثة الحركة النسوية الاسلامية فى مصر فى اطار التطورات التى يمر بها المجتمع المصرى بصفتها جزء لا يتجزأ من هذا المجتمع وانعكاس لما يحدث بداخله.

وقد توصلت الدراسة الى ان فعّالية الناشطات الاسلاميات فى مصر قد ولدت حركة اسلامية تقوم على اعادة تعريف دور المرأة فى المجتمع المصرى يقاوم هامشيتها و يخرج بها الى العديد من المجالات العامة التى كانت مقصورة على الرجال مثل مجال الدعوة فى المساجد. وعلى الرغم من وعى سيدات هذه الحركة بأنهن يقمن فى سبيل ذلك بتحدى الرجل، الا انهن يفعلن ذلك ليس من اجل التحدى ذاته ولكن من اجل التقرب الى الله. وفى نفس الوقت، تقوم هؤلاء الناشطات بمساعدة النساء بطرق شتى كتعليمهم القراءة والكتابة واعطائهم دروس دينية وتقديم المساعدات المادية لهن ابتغاء مرضاة الله. وهنا، تحقق الناشطات الاسلاميات تمكين الذات عن طريق اتقان الممارسة الدينية بغرض الوصول الى الصورة المثالية للمرأة المسلمة. وبناء عليه يأتى التمكين كحاصل لممارسة الدين

حقوق النشر محفوظة لقسم النشر بالجامعة الأمريكية بالقاهرة
١١٣ شارع قصر العيني ، القاهرة – مصر
طبعة أولى: ٢٠٠٣
جميع الحقوق محفوظة. ممنوع اعادة طبع أى جزء من الكتاب أو حفظه بعد تصحيحه أو نقله فى أى صورة و بأى واسطة الكترونية أو ميكانيكية أو تصويرية أو تسجيلية أو غير ذلك بدون التصريح المسبق من صاحب حق النشر.

رقم دار الكتب: ٠٣/٣٢٥٥
الترقيم الدولى: ١ ٨٠٣١ ٤٢٤ ٩٧٧

بحوث القاهرة في العلوم الاجتماعية

مجلد ٢٤ عدد ٤ شتاء ٢٠٠١

صيغ التمكين: ناشطات اسلاميات فى مصر

شيرين حافظ

قسم النشر بالجامعة الأمريكية بالقاهرة